WITHDRAWN

ASIA HOME

Inspirational Design Ideas

MICHAEL FREEMAN

TUTTLE Publishing

Tokyo | Rutland, Vermont | Singapore

Published by Tuttle Publishing, an imprint of
Periplus Editions (HK) Ltd

www.tuttlepublishing.com

ISBN 978-0-8048-3983-9

Distributed by:

North America, Latin America & Europe
Tuttle Publishing
364 Innovation Drive
North Clarendon, VT 05759-9436, USA
Tel: 1 (802) 773-8930; Fax: 1 (802) 773-6993
info@tuttlepublishing.com
www.tuttlepublishing.com

Japan
Tuttle Publishing
Yaekari Building, 3rd Floor
5-4-12 Osaki; Shinagawa-ku
Tokyo 141 0032
Tel: (81) 3 5437-0171; Fax: (81) 3 5437-0755
www.tuttle.co.jp

Asia Pacific
Berkeley Books Pte Ltd
61 Tai Seng Avenue, #02-12
Singapore 534167
Tel: (65) 6280-1330; Fax: (65) 6280-6290
inquiries@periplus.com.sg
www.periplus.com

12 11 10 10 9 8 7 6 5 4 3 2 1

Printed in Singapore

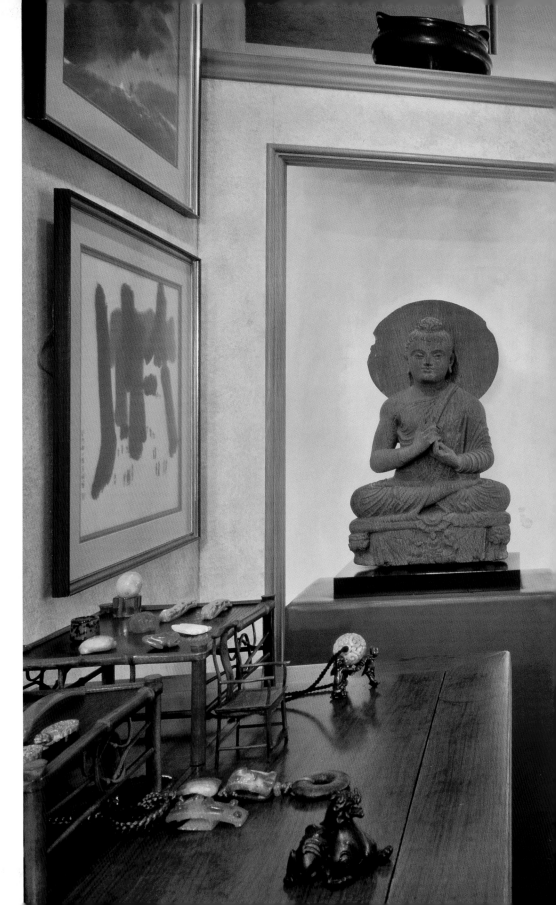

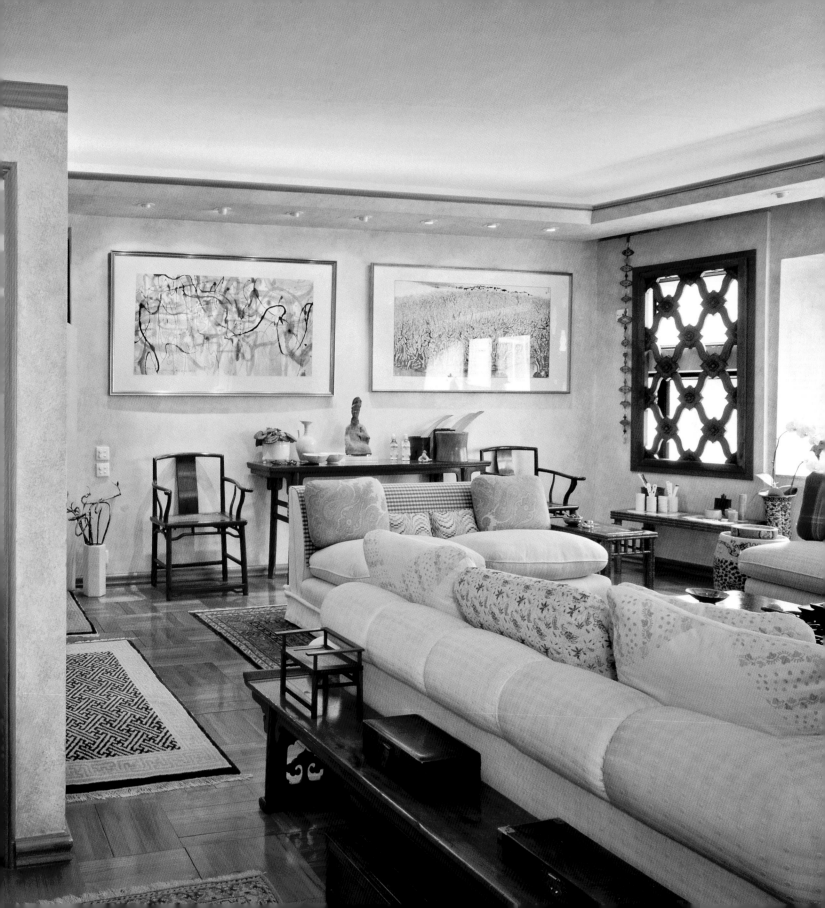

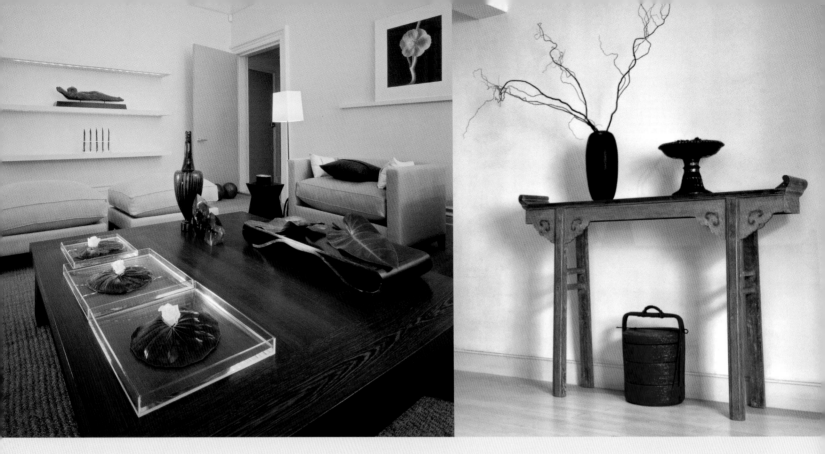

CONTENTS

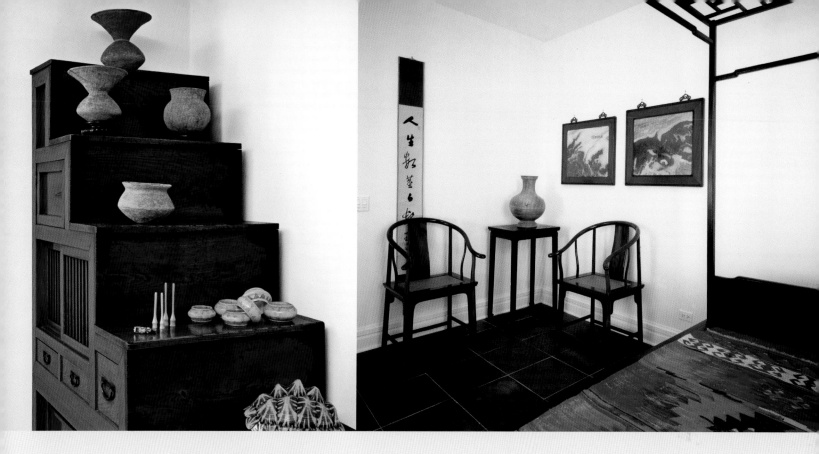

DESIGNING
AN ASIAN
DREAM HOME

The West has long been enthralled by Asian art, design and culture, from the period of Chinoiserie to early twentieth century painting. And of course that interest has been reciprocated as Asia absorbed influences from the West, beginning in the nineteenth century when, for example, the Japanese Emperor Meiji and the Thai King Chulalongkorn both eagerly adopted Western ideas and styles. Yet it is only relatively recently that this cross-fertilization has begun to affect thoughtful yet mainstream design and lifestyle. From the seventeenth to the nineteenth century, Chinoiserie and other versions of orientalism were largely confined to the decorative, and emphasized the exotic. As a result, the Asian influence on interiors tended to be the acquisition of a piece of furniture for its visual effect rather than for constant use or, in the case of wealthy patrons of Asian art and style, for a Chinese room or a Durbar room, with museum-like qualities.

The homes in this book, by contrast, are brimming with ideas that permeate a way of living, and what they show is a quiet revolution in design. The origins of this revolution, which dates back no more than about two decades, lie in a new and widespread willingness to experiment with ways of living and ways of organizing the spaces that we live in. Specifically, in Asia this means a relatively new design appreciation of Asian identity. This wave of new Asian home style actually began in the last decade of the twentieth century, with the beginnings of a recession that hit Japan first. Until about 1990, the Japanese economy had been on an ever-accelerating, lunar

A house in Shanghai's French Concession district displays an intriguing mix of furniture and art, including a black Qing cabinet, a painting by contemporary Shandong artist Pang Yong Jie and a low table with humpback stretchers.

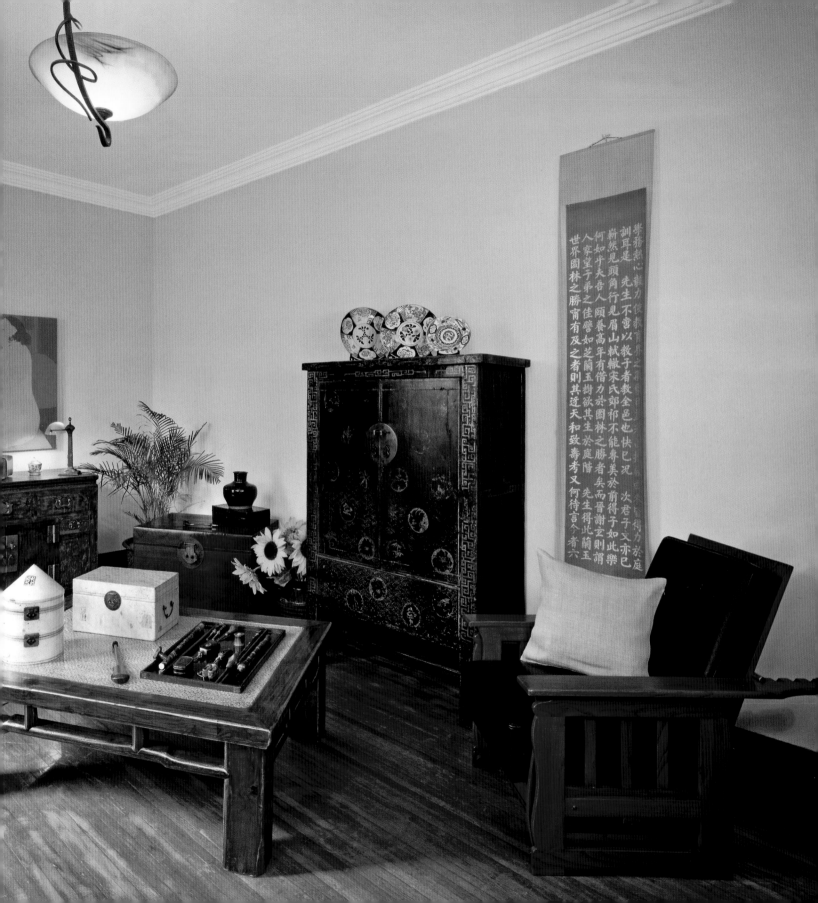

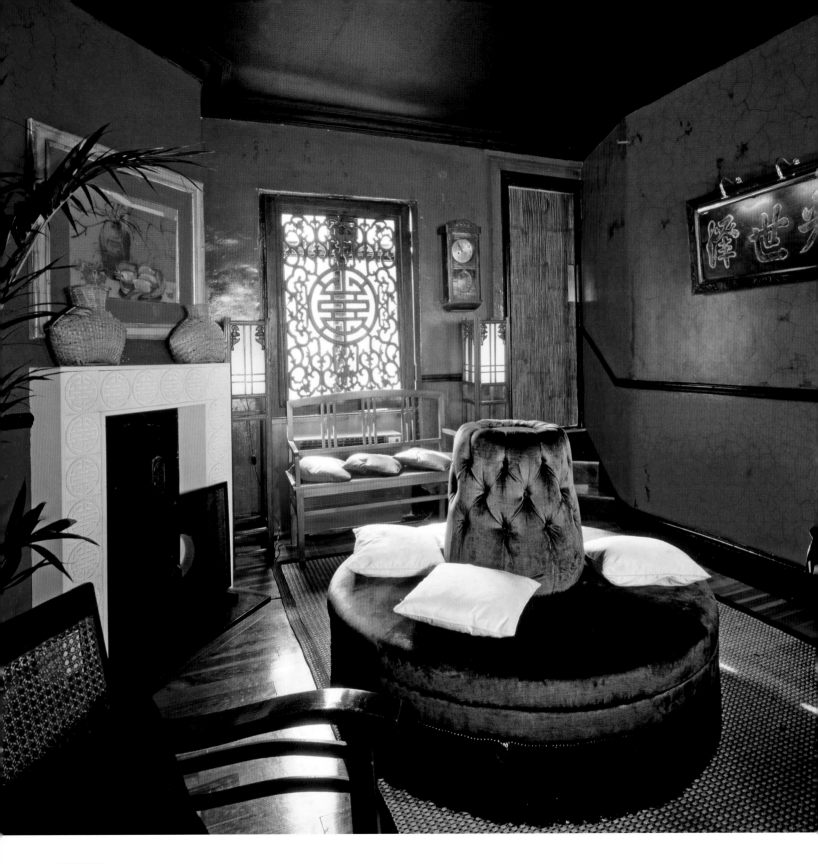

Designer Andrew Norrey has decorated this small lounge with glossy red and black, adding a craquelure glaze to the walls, to provide not only a rich background for accents in white and gold but also a sense of old Asia. The carved latticework window screen features the double character *xi*, meaning "happiness," frequently used in this circular stylized form for decoration, and this is carried over into a series of moldings around the white fireplace.

trajectory for almost three decades, and the effect on thoughtful design and good taste had been disastrous. If one thing characterized architecture and interior design of the period, it was being competitive with the West: overblown, exaggerated, with finally a kind of cartoon post-modernism. To a lesser extent (Japan being the economic and cultural Asian powerhouse of that period), this happened across Asia, from Bangkok to Shanghai. It was the start of the recession that put a halt not only to many elaborate projects but to this design free for all. More serious and younger architects and designers in Japan stepped back from internationalism and began to look at what they could take from the Japanese past and rebuild for contemporary needs and with contemporary technology. Kengo Kuma, Shigeru Ban and Terunobu Fujimori are three of the better known among this inspired group.

Other Asian countries began to follow as a new generation of architects and designers saw what was being quietly achieved in Japan, and also because a new generation of home owners wanted to experiment and were prepared to spend more of their income on turning their homes into places that expressed their personalities. This happened quite rapidly in Korea, Singapore, Bali and Thailand. In India and China, the two giants of the region, and ironically the two original sources of almost all the significant design and cultural ideas that influence the home, the process began slowly. India was for many years held back by

economic and financial restrictions until the liberalizing reforms that began in 1991. China's economic development too is relatively recent, and it takes time in any society for a middle class to develop—and then to pass through the stage of being satisfied with standardized comfort to an enthusiasm for interesting design ideas. But now that design evolution process is under way in India and China. With a fresh client appetite for exploration and for specifically Asian-themed ideas, they will become the new powerhouses.

There are three interlocking and interacting trends at work here. One is new appreciation for traditional forms. Of course, fine Ming furniture, for example, has always been appreciated by connoisseurs, and is now seriously expensive. But with high-quality reproductions (perhaps 'reproductions' is the wrong word; we should maybe say 'new workshops'), this clean, refined-to-the-ultimate style is now affordable and can demonstrate how well suited it is to a modernist interior. Indeed, one of the things that has made this new appreciation of the old possible is a willingness to use traditional pieces in contemporary settings, and you can see here how surprisingly adaptable such varied pieces as Japanese *tansu*, Thai gilded chests, Chinese rustic bamboo furniture, Japanese stone water basins and Indian beds can be when placed in fresh contexts. This is the cue for the second trend, the absorption of Western contemporary styles into Asia, styles that carry a

Clear geometry against a white backdrop is the theme for this Pudong apartment designed by owner Zhong Ya Ling. A jade *bi*, one of the oldest styles of Chinese artifact, is prominently displayed on a stand faced with polished black granite, and its color picked up by the cycad in a glazed green pot.

strong legacy of modernism, ex-Bauhaus and Mies van der Rohe: white, bright, geometric and functional. The ways in which they are being melded with Asian ideas gives them a specific character. The third trend is the inventive reinterpretation of traditional Asian concepts, techniques and materials by architects and designers. Look at Rajiv Saini's use of ancient iconography and Jain symbolism in a modern Mumbai apartment, Shao Fan's reworking of Chinese courtyard living in modern brick and glass, or Michimasa Kawaguchi's curved *shoji*-walled *tatami* rooms.

What we aim to do here is to give practical inspiration and to define, by example, the ways in which Asian attitudes to space and living, and Asian design solutions, can energize and combine with Western contemporary themes. Of course, not every example here is translatable or capable of being replicated. The oval island of a dining room in Kengo Kuma's Water/Glass House is and should remain unique, and even adapting this spectacular idea in some way would be horrendously expensive, yet the ideas behind it—transparency, the merging of a house with the sea, and the way in which water can flow into glass and vice versa—are themselves inspiring. Pearl Lam's exuberant gathering of styles (European baroque juxtaposed with Qing, for example), her celebration of contemporary Chinese art and intense color combinations inspire in a different way: they are marvelously

individualistic, full of confidence, and a perfect antidote to the boring but increasingly common advice of the style police to tone things down, take out the color, keep quiet and don't surprise.

How many times have you heard or read that neutral and minimal are somehow inherently preferable to ornamented and exciting (or loud, as its critics say)? This trivial kind of attempt to lay down design rules, all too common in second-tier interiors magazines, is the antithesis of inspiration. It is just a way of recommending safe rules for safe design. In reality, there are many diverging styles, and individual flairs that diverge even from these. Not every home design here will please or suit everyone, and nor should they. If you are taken by thoughtful, refined simplicity you will find more to inspire you in the contemporary developments shown here of Japanese *sukiya* style (simplicity, natural finishes, natural materials with painstaking consideration) than in the elaborate, exquisite *rococo* of Thai cabinetry, Korean brass cupboard fittings or late Qing furniture. But both are wonderful in their own way. To make this inspiration practical, the book is organized not by source but by use. Rather than present the many homes here each in its entirety, we have selected from them by function, dividing the home, and the book, into its basic units, beginning with the living space, followed by dining, bedroom and bathroom. In the case of the first, space is probably a more appropriate description than room, as it reflects what

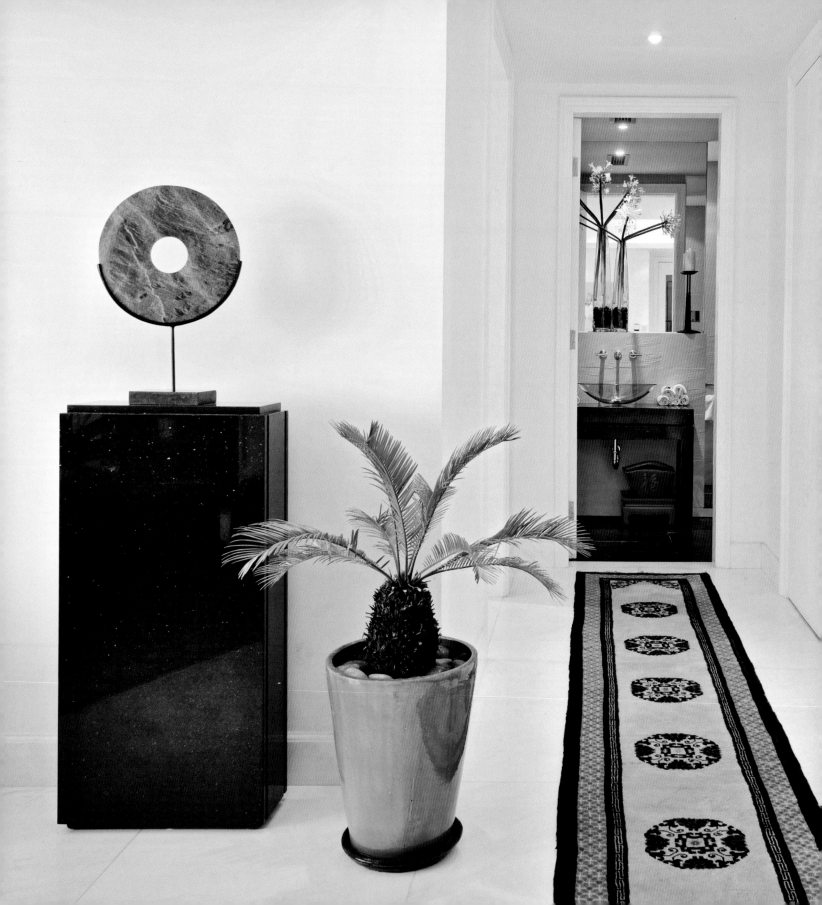

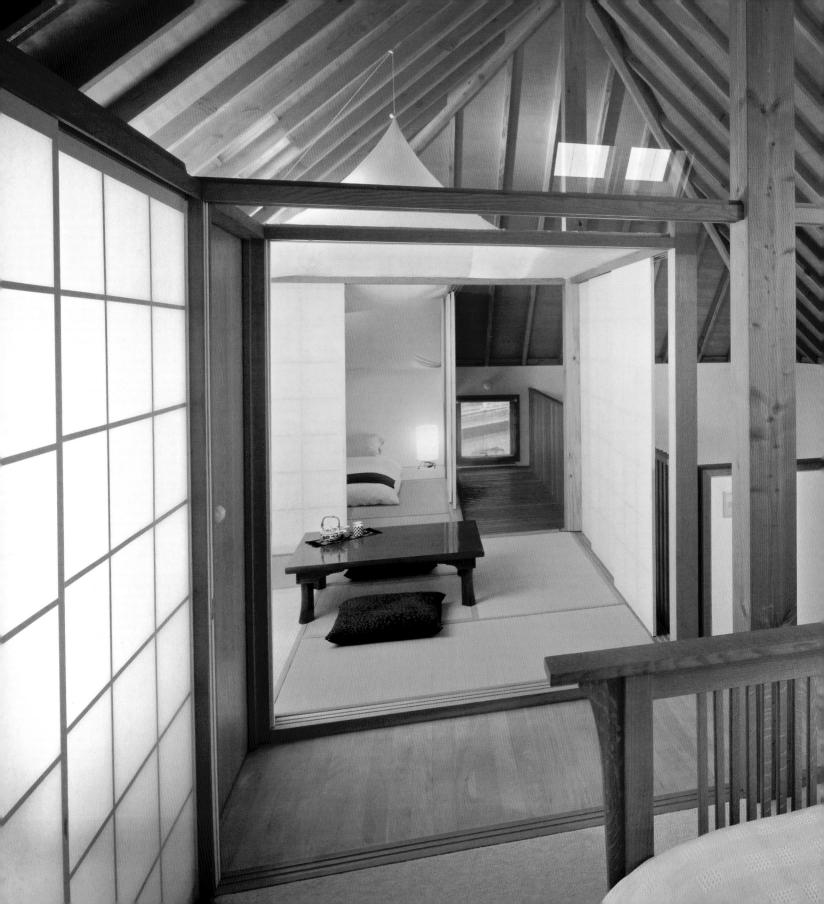

Two adjoining *tatami* bedrooms linked by a common area with floor-level seating in a house in Yokohama. Designed by architect Ken Yokogawa, the mezzanine suite is suspended below the exposed rafters over the main living area, and each room features a tent-like ceiling of stretched white lycra. Sliding paper *shoji* screens allow privacy or connectedness.

is now a more flexible attitude generally to what defines the "living" component of a home. This is one area where Asian practice has had a deep influence, in ways that vary from the interior flowing into the exterior to multiple-use and variable-dimension spaces that have been refined for centuries by the Japanese and Koreans. These chapters on interior spaces are followed by the garden, which spiritually and conceptually is quite distinct in Asia, and for these special qualities is being enthusiastically adopted all over the West. There was one earlier period of Asian garden influence, in the seventeenth century, when Chinese principles inspired the naturalism of English landscape gardening. The new influence today is on structure, simplicity and the ability to create and define a garden in the smallest of spaces—of obvious value in our increasingly urban lifestyles. The book closes with a more detailed look at the individual items of furniture and details for which Asia is famous, and how these can be used in contemporary settings. Above all, this is a book of ideas—ideas from many different architects, interior designers and independent home owners, who have all taken Asian themes, concepts, even individual pieces of furniture and shown how they can enliven and enrich a home. Ultimately, modern and inspiring Asian homes are an intelligent fusion, to use that overworked term, between West and East and between traditional and contemporary. This fusion works at different levels, from the surface level of shape and form, down to concept and underlying principles, as we will now show.

DESIGNING AN ASIAN DREAM HOME

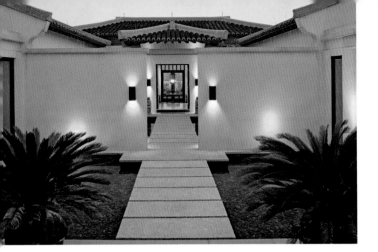

ENTRANCES WITH
A PURPOSE

Throughout Asia, the entrance to a home is by tradition not simply an opening to an interior space. It also protected the privacy of the house, of special importance in those traditional designs which featured an interior courtyard or central open space. This included the many variants of the Chinese courtyard dwelling, and also the Indian *haveli*. The entrance needed to provide a kind of baffle so that the interior open area was not directly exposed to the street, and this typically took the form of either a right-angle turn or a screen. The circumstances may have changed radically but the contemporary legacy of this is that the space immediately inside the entrance—what would be called the vestibule in Western tradition—is an integral part of the design. In today's Asian home it provides an opportunity for display and presentation as well as a small space in which to pause and where guests can be greeted.

Top A contemporary reworking of a Chinese grand entrance through axially aligned courtyards is seen in this approach to a villa in Fuchun, near Hangzhou, designed by Belgian architect Jean-Michel Gathy. The repetition of light fittings on the plain white walls reinforces the axial theme and the succession of spaces.
Right A Japanese tradition is the *kutsunugi-ishi*, the entrance stone for removing shoes before entering a house or teahouse. This modern version is a slab of black granite.

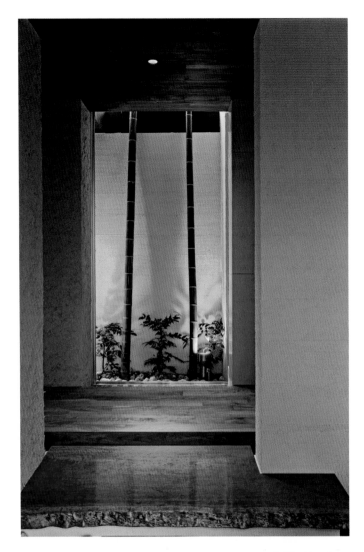

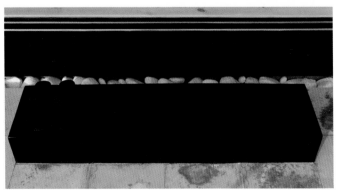

Left From the doorway in this contemporary Japanese dwelling south of Tokyo, visitors first step up onto a rough-hewn slab of wood. The designers, Ken Architects, created a display facing the entrance in the form of a shallow lightwell extending through two stories, containing two *nanten* bamboo.

Right In a Japanese house south of Osaka, designed by architect Akira Sakamoto, the right-angled entrance does two things: it provides a baffle to shelter the immediate interior from view, and through the tightly packed granite *gorota-ishi* stones set in concrete it draws the exterior pathway into the interior.

Far right In place of the traditional "shoe-removing stone" at the entrance to Japanese homes, architect Ken Yokogawa designed this raised sculpted pedestal like form in white concrete.

Below A domed ceiling, decorated in distressed gilding, flanked by molded columns and hung with a large 1930s Shanghai lantern, surprise the visitor to a modestly scaled house in the village of Shek-O on Hong Kong island.

Below right An interpretation of a traditional Chinese moongate door, in rich red, forms a striking entrance to the master bedroom in the Pudong apartment of Zhong Ya Ling. The off-centered inner-to-outer frames of the doorway add delicacy and interest.

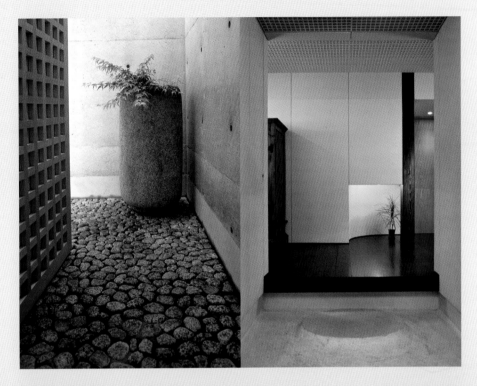

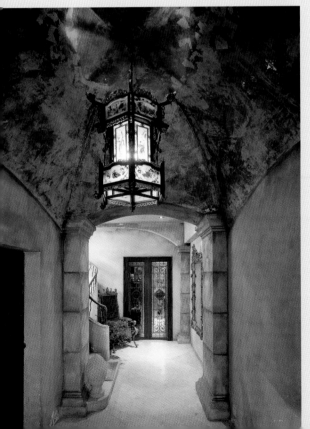

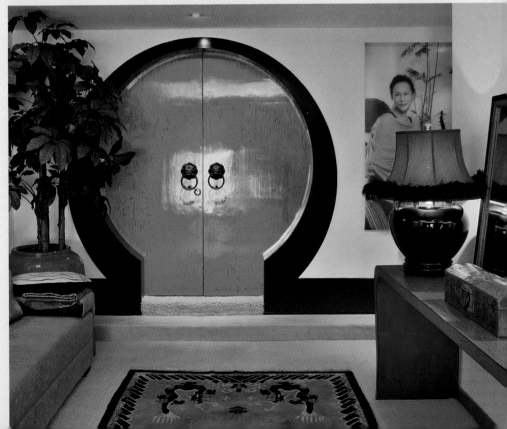

Left A diagonally sited concrete wall clad with red sandstone at the entrance to the courtyard of a modern Indian home in Udaipur is a contemporary interpretation of the traditional *modh* or baffle wall that shields the view of interior spaces from the outside. The design, by Rajiv Saini, contains a water spout in the form of a brass cow's head.

Below left Inspired by a contemporary tea ceremony room designed by Shigeru Uchida, this entrance to a small house in sandblasted glass supported by a single thick bamboo culm both seals the room from the outside and creates a light source when seen from inside.

Below right Extreme simplicity and natural textures feature in this minimal entrance to a house in Kyoto designed by Hiroshi Yoshikawa. The unpainted wooden door slides into a recess in the white wall, revealing a small rear garden.

Right A spectacularly modern Japanese solution to the entrance features striking contrasts between materials and textures in this design by architect Chitoshi Kihara. The approach crosses grass, gravel and concrete, then passes a mirror-finish stainless steel column and a single entrance stone before reaching a glass-walled *tatami* room.

Opposite below left The entrance to this contemporary Tokyo home features a lower area for taking off shoes immediately inside the sandblasted glass wall and door, before stepping up to the wood ground-floor level. A double return of boxed-in steps recalls the profile of the traditional Japanese step *tansu* cupboard.

Opposite below right A diagonal cut into a house clad entirely in vertically planked red cedar, by architect Kohei Sato, is enlivened by a single splash of color, a glossy red door reminiscent of lacquer.

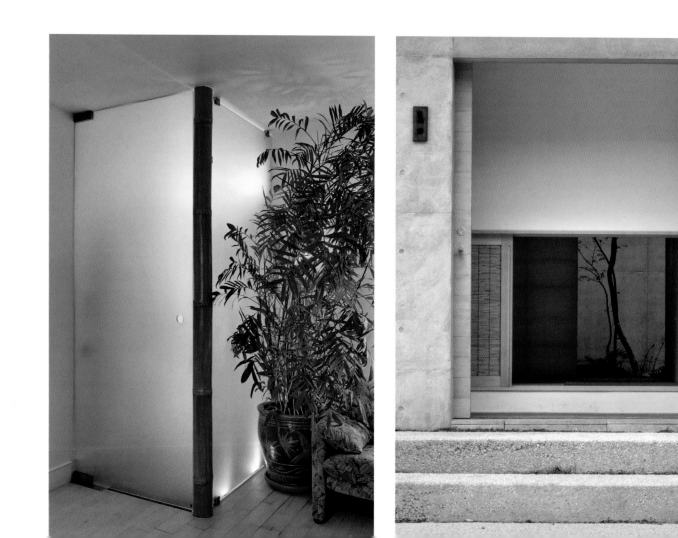

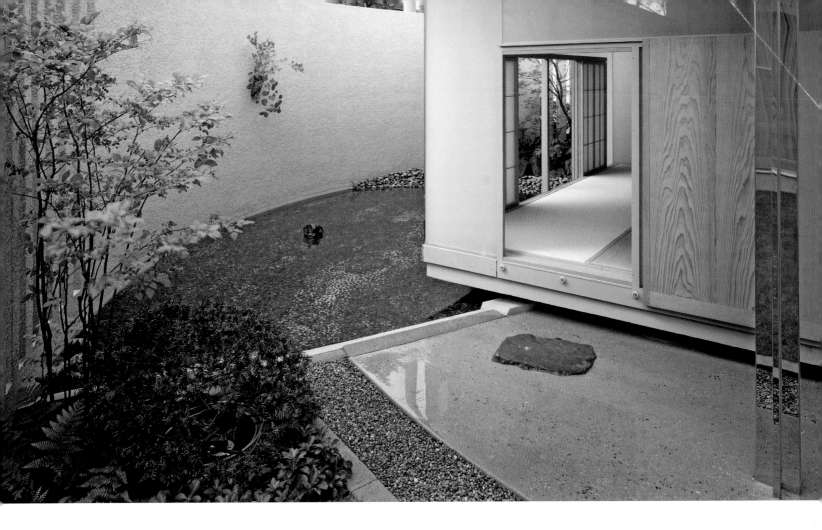

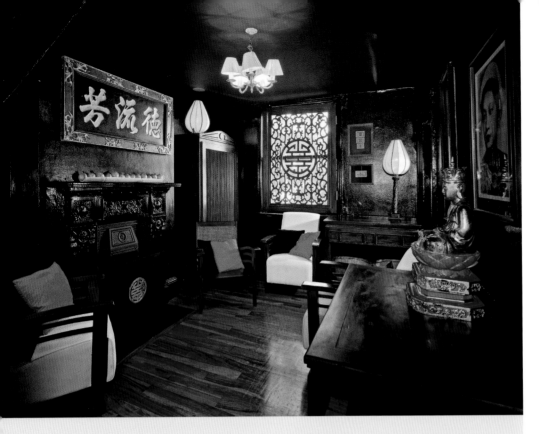

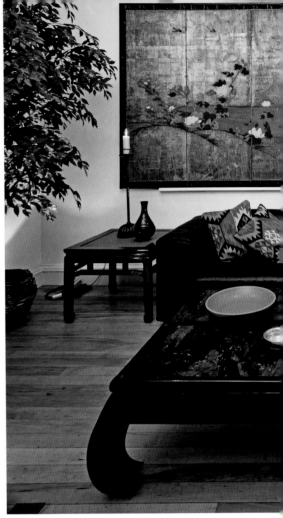

Above A sense of cosy intimacy in this room is created by using rich and dark colors: glossy black and deep natural wood, accented with magenta and gold. Asian elements, including screens, were sourced from China and Vietnam.

Right A low black lacquer Japanese table inlaid with mother-of-pearl and with elegantly shaped inward-curving feet, is aligned in a formal arrangement with the sofa and a silvered six-panel screen hung on the wall behind.

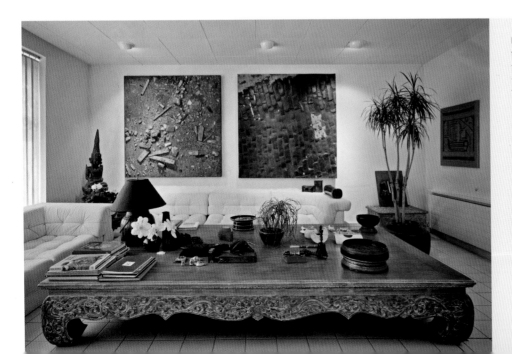

Left A large and exquisitely carved low Thai table—in these dimensions such tables were traditionally also used as beds—is the main focus of this white-and-oatmeal living room. Two works of art by Mark Boyle form a textural and tonal match.

Right Ming furniture and sandblasted glass and steel are successfully combined in this open-plan living space in a Hong Kong apartment. The austere lines of Ming tables, chairs and cabinets have an enduring modernist appeal.

Far right A more opulent use of Asian furniture in a Western apartment (New York's Fifth Avenue) sets a late sixteenth-century Japanese screen against a late seventeenth-century Chinese carpet, with *huanghuali* horseshoe-back chairs of the period.

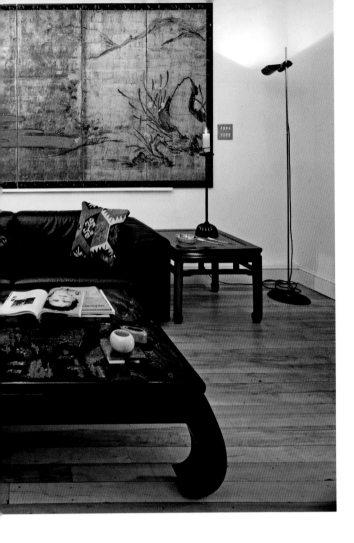

AN ASIAN **STYLE OF LIVING**

Today's Asian living room is a relatively recent concept, reflecting changes in the way we organize and use our dwelling spaces. In particular, it combines two functions that were formerly separate. One is the space reserved for the family's day-to-day activities; the other is the space for receiving guests and entertaining. This second function is no less important now than in early times, but it has to co-exist with the comfort of normal living. Some common themes run through the different Asian cultures, from India to Japan. One is the focus on an inward-facing area of seating, usually around a low table. Another is that some of the seating at least should be soft and designed for comfort. And then there is the need for a prominent work of art on at least the major wall space, a need fulfilled by a wide range of traditional screens and also by the recent explosion of contemporary art which, as in the West, tends more and more to favor size. Art is one particular area in which personality can be displayed because, above all, the living room is the central space in any home that defines the taste and personality of the owner. These are as varied as you might expect, and within the functional needs just described there are infinite possibilities, from color schemes to the use of traditional or modern furnishings.

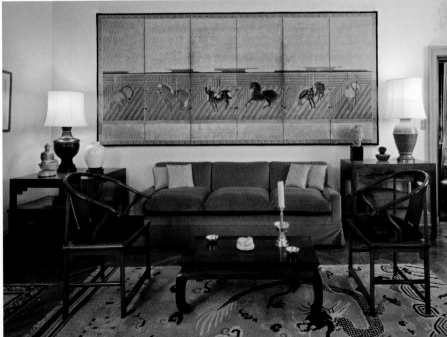

Left Beijing artist Shao Fan furnished his living room with a geometric layout that matches the house, which he designed himself. Modern sofas are juxtaposed against more traditional pieces, while the wool-lined chair is his own creation from a Tibetan chest. The painting is from his black series.

Below A 1950s apartment on Malabar Hill, Mumbai, has been reworked sensitively by architect Bijoy Jain, who rendered the interior in an Indian lime plaster finish known as *araish*, lightening it and providing plenty of blank space for the owners' extensive collection of contemporary Indian art.

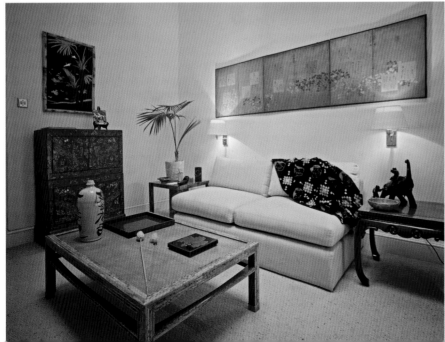

Above Modern Indian furniture in a severe geo-
metric design and a five-panel painting by a
contemporary Indian artist form the focal points
of the large living room, with its polished granite
floor, of an Indian house in the farmlands between
Delhi and Gurgaon.

Left Low wall lighting adds an intimate feel to this
cosy arrangement of rustic Chinese table, Tibetan
cabinet and Japanese screen.

THE NEW ASIAN LIVING ROOM

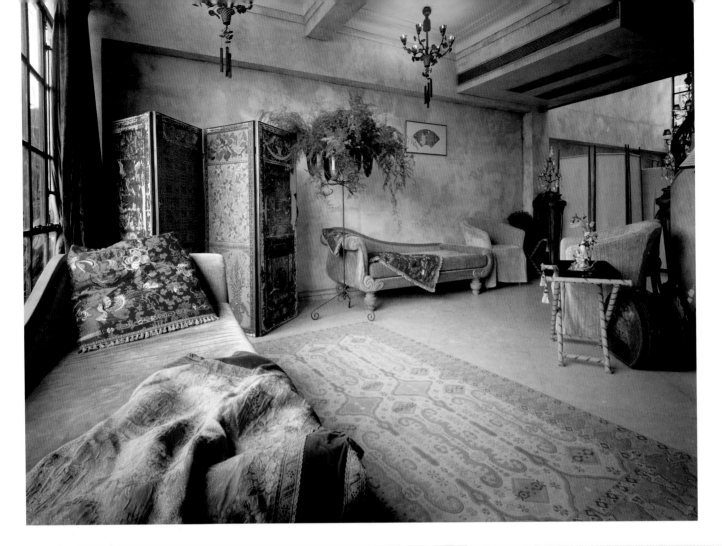

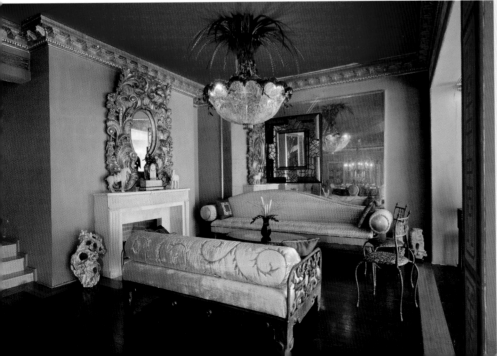

Above Green and red fabrics from a mixture of Chinoiserie and Western baroque make strong color accents against distressed walls, a faded carpet and screens.

Left Red, turquoise, purple and gold make up the luxurious color theme in the drawing room of Pearl Lam's Hong Kong apartment, which features work also commissioned for her Contrasts Gallery, including a feathered "Coco=cabana" chandelier.

Right Zhong Ya Ling, the owner of this apartment in Pudong on the Huangpu River, produces her own range of fabrics, and exercised her strong color sense in the living room by combining blue, red, yellow and green as accents held together by the overall white space.

A RICH COLOR **PALETTE**

Using vivid colors in an interior calls for confidence, which is to say confidence in your own judgment that certain strong colors will go together, and confidence also that the effect will not overwhelm visitors. Fortunately, a safe starting point is the tradition of a rich color palette and certain specific hues in some Asian cultures. In Chinese tradition, which permeates the design sense of many other Asian nations, colors have special significance in their associations with life, the seasons and knowledge in general. They are *equivalents*, and because of this, contrasts are welcomed. Not only this, but Chinese color theory is far from the Western model of complementaries and opposites, and designers do not feel obliged to follow the familiar "rules" of harmony. The striking interiors of Pearl Lam, shown here and in other parts of the book, are perfect examples of designing successfully with contrasting and rich colors. Red, of course, is the most significant color in Chinese culture, where it has long been seen as a life-giving hue, and for its energy and warmth makes an excellent start when composing in this primary way for a living room. And, philosophy apart, vivid colors are throughout Asia associated with celebration and energy.

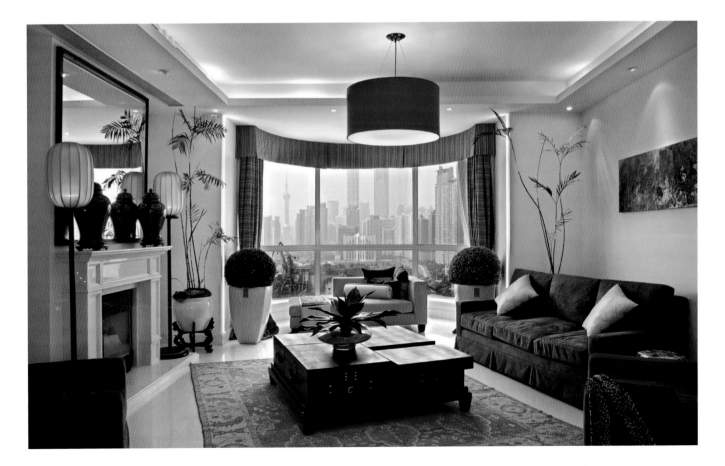

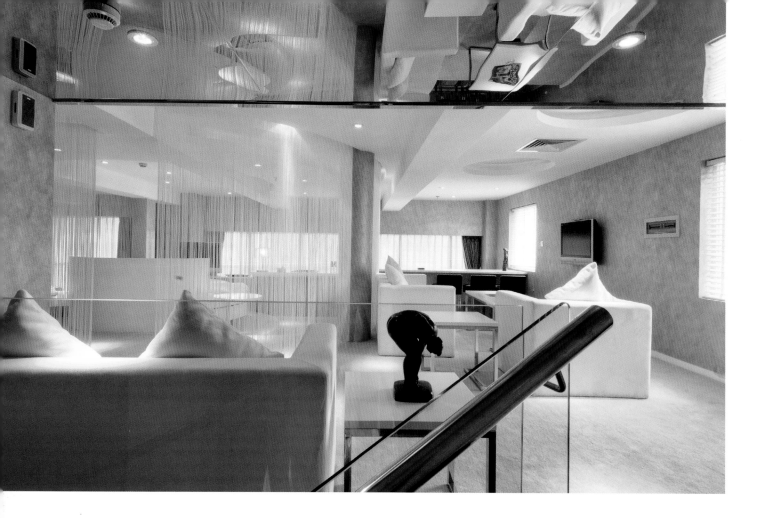

NUANCES **OF WHITE**

A very different color aesthetic from the drama of strong hues, and yet still within Asian tradition, is to bathe interiors in white. While in principle white connotes coolness and calm, it is also highly responsive to the effects of imaginative lighting, the nuanced reflections of other gentle colors and the occasional accented contrast with a small vivid color. Aesthetically, white reflects that side of Asian culture which plays to restraint, simplicity and a certain formality. It is also the color of modernism *par excellence*, and this Western design tendency has been eagerly absorbed by contemporary interior designers in Asia. There are two basic design ways of using white. One is to play with the subtleties of tonal whites, either by applying slightly different color shades or by relying on white's great capacity for reflecting other hues. The other is to make white the backdrop for a small yet striking color accent. In the former, it is important to know how changing color temperature will be reflected—cool from north-facing windows, for example, and the useful contrasting warmth from (non-fluorescent) interior lighting. White responds strongly to this contrast, and care should be taken in choosing the color quality of the newer CFL lamps. Even greater subtlety is possible by choosing slightly different chromatic whites for different wall and ceiling surfaces. The second way of using white is as a foil and backdrop against which to locate a carefully chosen accent, as in the Indian interior overleaf.

Opposite Variations in texture, from the smooth finish of the ceiling to the carpet, modulate this white-on-white penthouse overlooking Suzhou Creek in Shanghai, while downlighting spots provide the drama and contrast.

Left Lighting and color accents define this white space in designer Rajiv Saini's own apartment in Bandra, Mumbai. A boxed-in light also serves as a shelf for a row of cast green glass Buddha images, with orange marigolds in bowls on the table.

Below left A courageous choice by Chinese architect Jiang Tao was to render this interior entirely in white, with no hint of color accent. It gives the space a slightly other-worldly feeling, and focuses attention on the shapes of furniture, in particular the square openwork screen.

Above The upstairs living room in jewelry designer Munnu Kasliwal's Jaipur weekend farmhouse features a daybed upholstered in white, with bolsters, wall hangings in a niche above, and local rustic furniture.

THE NEW ASIAN LIVING ROOM

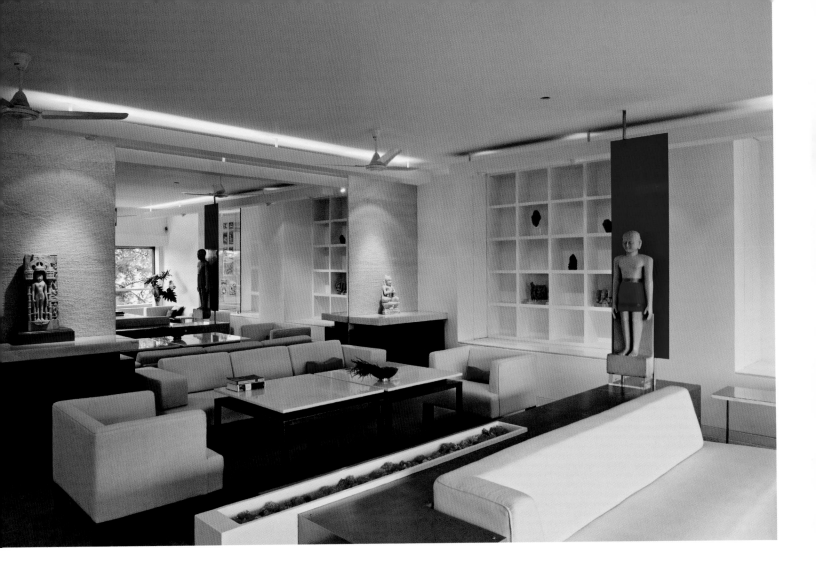

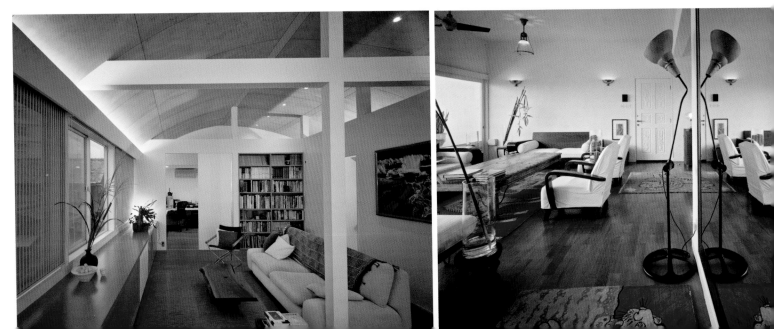

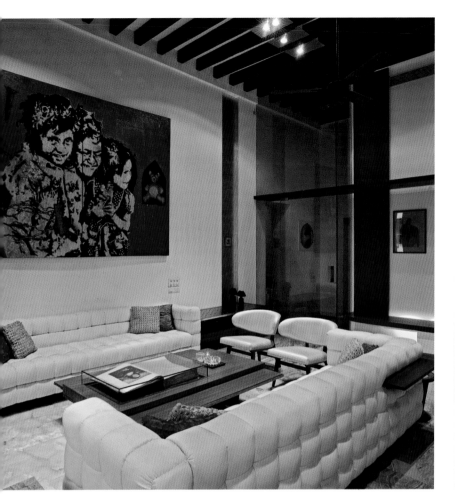

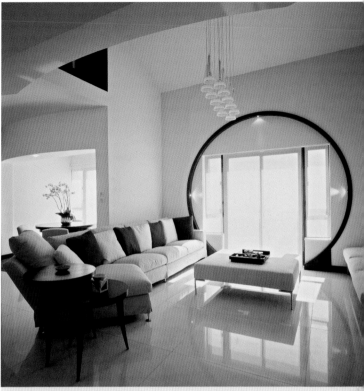

Above Polished tile flooring and a white-and-cream finish to this living room in a residence on Hong Kong's Peak reflect and expand the light flooding through the focal point of the space, a moongate arch framing the principal window.

Opposite above Two bands of color divide this white-themed apartment in Walkeshwar, Mumbai: a red lacquered metal backdrop to a white marble Jain statue and a trough filled with marigolds.

Above The living room of a house on Malabar Hill, Mumbai, makes use of white upholstery and walls to give prominence to the contemporary Indian painting.

Far Left Architect Yasuo Kondo's concept for this house in Tokyo was to enlarge the sense of space in the open-plan living area by exposing the curved wooden roof structure and using white surfaces to redistribute the light.

Left In a conversion of a 1960s apartment in Singapore, a white ceiling and walls and white upholstered art deco chairs lighten the teak flooring and collection of Mongolian tiger rugs.

Right In the conversion of a Shanghai lane house from the 1930s by architectural practice sciSKEW, an all-white finish takes full advantage of the light flooding through the art deco French windows.

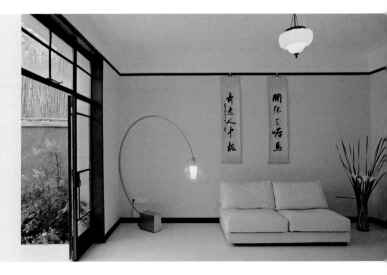

TROPICAL **LIVING**

A large swathe of Asia lies within the tropics, from southern India, Southeast Asia to the Philippines, and this has inevitably had an effect on the way dwellings are constructed and in the ways in which people use their living spaces. Traditionally, the architecture of homes has aimed at coolness, shade, a flow of air and, where the setting permits, an integration between the interior spaces and the exterior garden and surroundings. This has evolved over centuries and was perfected for local conditions, but came abruptly to a halt with the arrival of inexpensive air-conditioning in the mid-twentieth century. Fortunately, there is now a revival of interest in living *with* tropical nature rather than sealing it off, and while air-conditioning and apartment living have made this style of open living no longer essential, contemporary design has shown a healthy interest in developing ways of making inside and outside interconnect. In contrast to the veranda concept that we shall see later in this chapter, exposing the principal living room to the exterior means acknowledging the effect of humidity, heat and strong sunlight with a high UV content. One solution is to choose materials for furniture and furnishings that will withstand and even thrive in outside conditions. Plastic and weather-resistant aluminum are excellent, but natural materials like certain woods and bamboo can weather well in humid conditions.

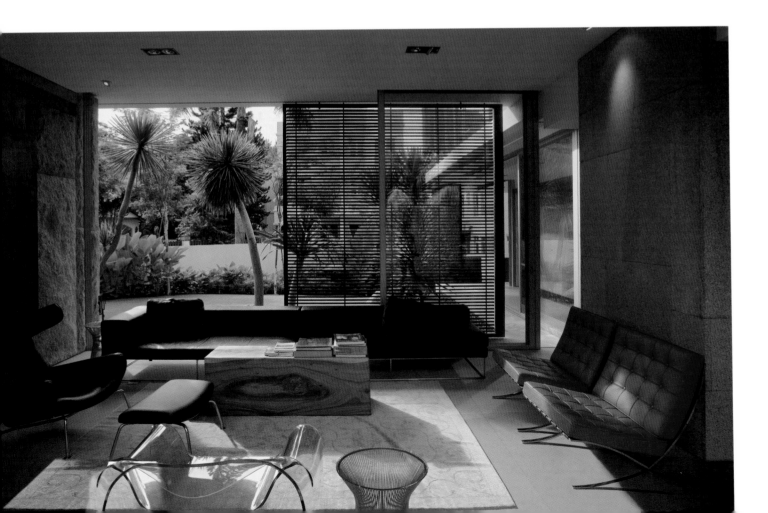

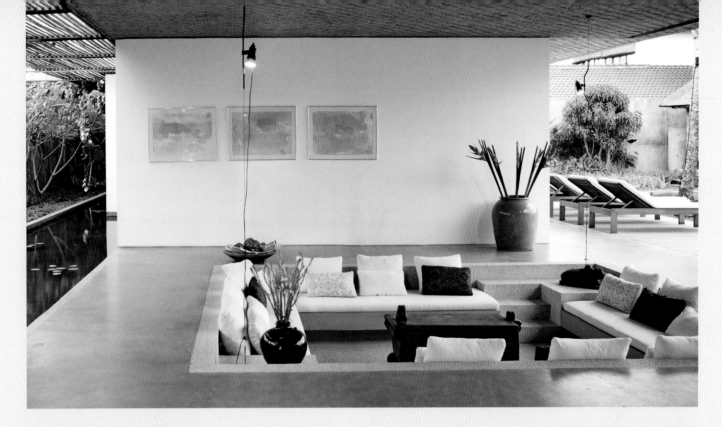

Left The living room of the Khai House, Singapore, by architect Ko Shiou Hee, opens completely through sliding glass doors on two opposing sides to the garden, so that the space integrates fully with its tropical surroundings.
Below A steel frame allows the upper floor of this contemporary house near Pattaya, Thailand, to project over the decking that extends the living room.

Above Another living space that opens front and back to the exterior is in this house in Seminyak, Bali, designed by Ian Chee as a modern interpretation of a traditional Balinese dwelling. The seating area is imaginatively sunk below grade.
Below A white wooden frame hangs mid-level on the glass corner of this sitting area for a suite in a house in Udaipur, India, and gives a shaped view of the garden.

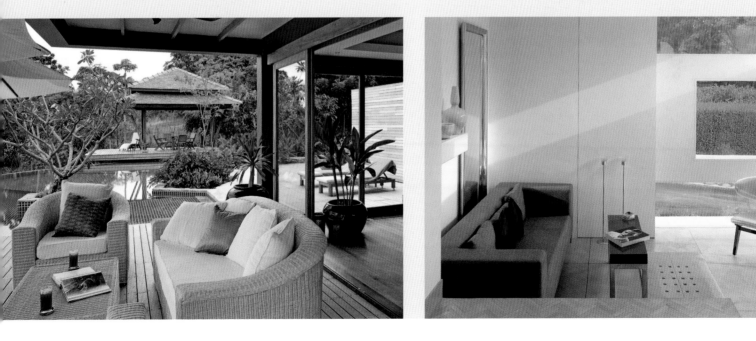

CONTEMPORARY **COMFORT**

What all of the living rooms on these and the following two pages have in common is that
they aim for a particular level of luxurious comfort, both physically and visually. These are living
rooms for relaxation, and essential for all of them is the softly upholstered sofa, which is the West-
ern development of the daybed. Long gone are the days when puritanical critics complained, as
they did in the eighteenth century, that lounging on sofas would encourage people to drift off
into fantasy worlds and lose their moral bearings. Lounging in comfort is fully a part of enjoying
the home. From Corbusier classics as in the Japanese living room above right, to furniture designed
by the architect to coordinate with the design of the space, there is an endless choice of contem-
porary sofas and armchairs available. Sofa seating inspires conviviality, and in almost all cases calls
for an arrangement in which the seating is gathered around, either two sides of a corner, or facing,
and this tends to dictate the layout of the room. Coffee tables of one kind or another play their
role here as focal points around which the seating revolves, and also as surfaces for drinks, snacks
and reading material. With rest and relaxation at the top of the agenda rather than stimulation, the
overall design also plays its part. Clean lines, simple color schemes and a lack of fussiness character-
ize this laid-back yet elegant style. The only exception is, in several cases, a single viewable point of
interest, such as the Indian mural here, a large piece of art, or even a picture window view.

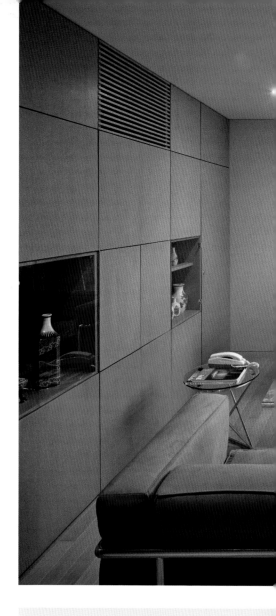

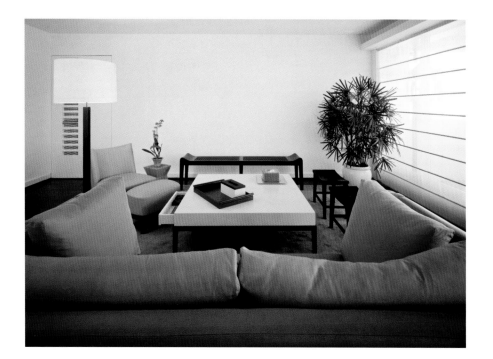

Left The color palette in this Kowloon
apartment by Ed Ng and Dan Lee is
in natural tones of stone, cream and
lilac, offset by a bench and stools in
black by Christian Liaigre.
Above In this house in Sakuragaoka,
Japan, designed by Kunihiko Haya-
kawa, the wood-paneled living room
opens out onto a veranda by means
of an updated design of *shoji* screens
in translucent polycarbonate.

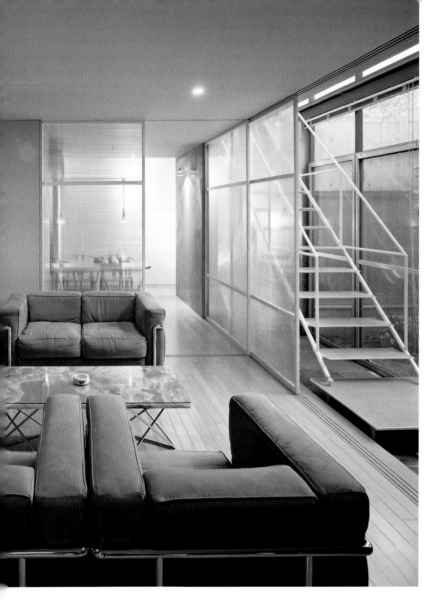

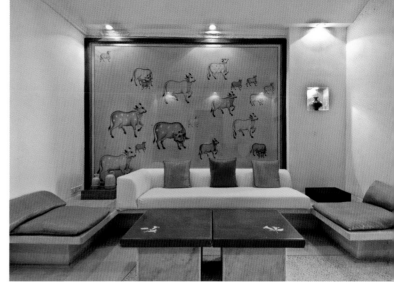

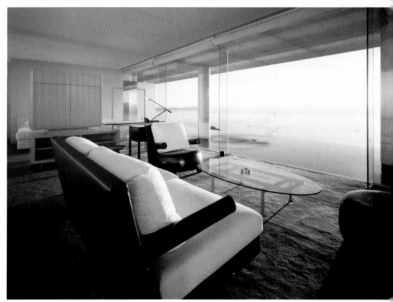

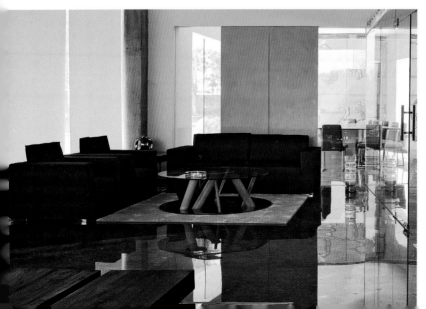

Top In this cool modern conversion in a restored Rajasthan fort, a large glass panel painted with images of the bull Nandin, Lord Shiva's steed, almost fills one wall.
Above A large expanse of glass features in this luxury villa overlooking the seaside resort of Atami, near Tokyo, designed by Kengo Kuma. This sitting room takes full advantage of the view, with ample sofas and a textured carpet.
Left Double-height glass walls modulated by translucent blinds and sliding gray screens give views out to the farmlands surrounding this house near Delhi. The polished marble floor doubles the reflections and helps to spread the light around the space.

Right The living room in an apartment in Shanghai's 1930s-built Grosvenor House combines modern white furniture with 1950s black leather chairs, a tapered Ming cabinet set into an alcove and a luxurious color theme of warm beige and black.
Below The living room of an apartment designed by Kelly Hoppen, in soft and muted colors and comfortable textures. A large *wenge* table supports shallow plastic trays filled with water, in each of which floats a simple arrangement of a lotus leaf topped with a white rose.

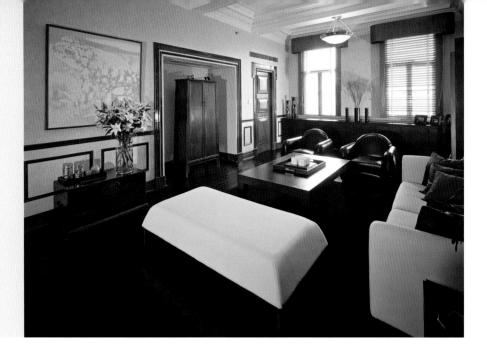

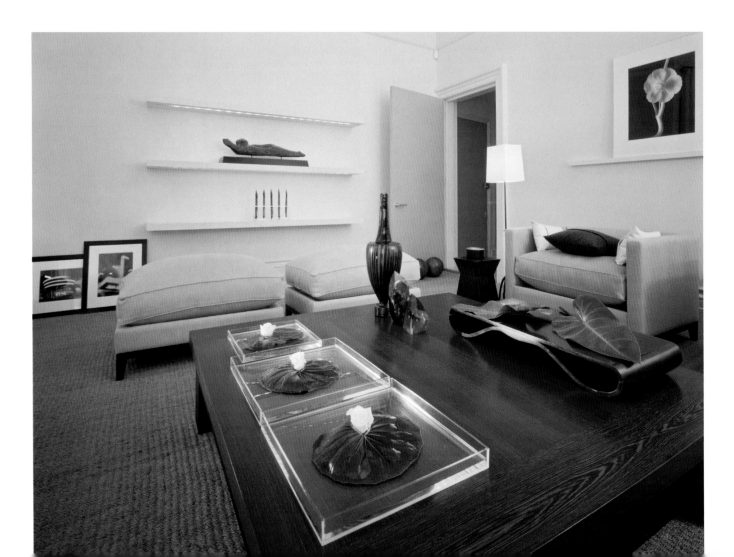

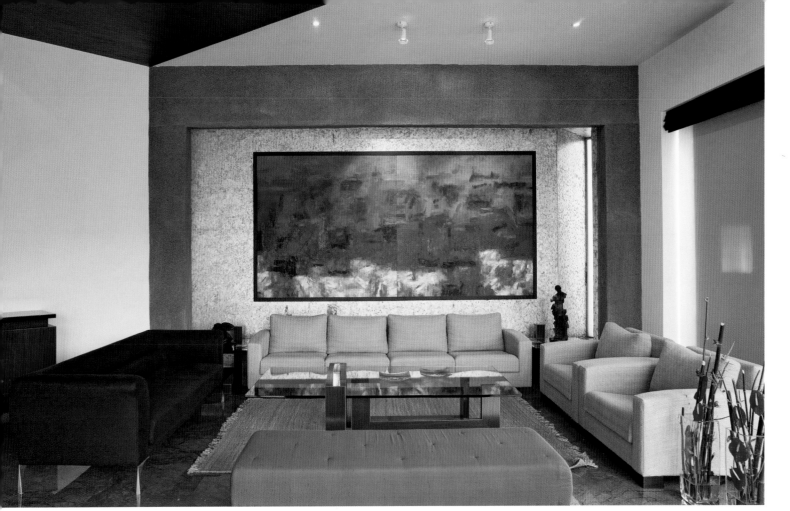

Above A wide variety of natural stone is available in northern India, and designer Rajiv Saini has made use of several different textures in this living room in a family house on the outskirts of Delhi. **Left** The living room of a weekend beach retreat in Walsad, southern Gujarat, designed by Aniket Bhagwat and his wife Smruti Prabhakar, has sliding glass doors bearing black-and-white photographs of coconut palms that open onto a courtyard dominated by a large porthole-themed light set into one wall.

THE NEW ASIAN LIVING ROOM

Right The living area of the Balinese residence of designer and bamboo enthusiast Linda Garland, in natural wood paneling, exposed bamboo ceiling and woven bamboo matting, is furnished in an eclectic mix of rustic furniture and *objets trouvés*.

Below The Smyth House, also in Bali, is furnished with locally made table and chairs, and a simple white-upholstered sofa.
Below right The *charn*, or traditional terrace area of a raised Thai house, built all in teak, has here been roofed over to provide a shaded space.

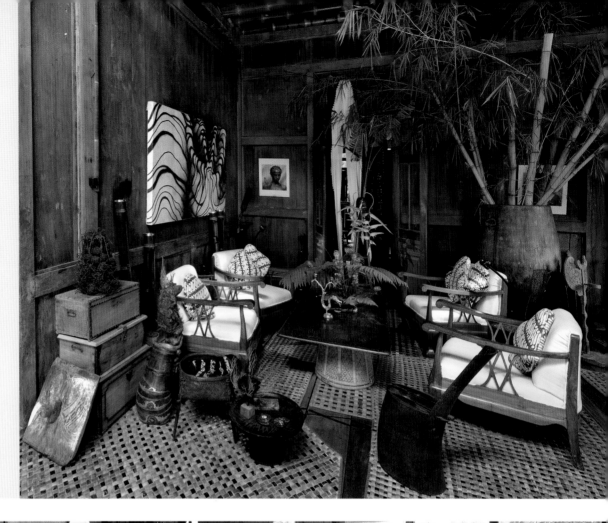

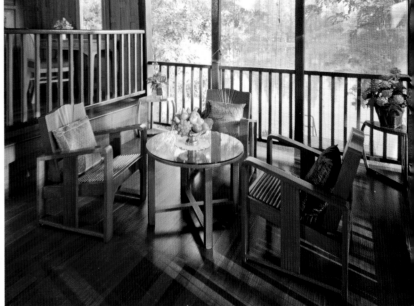

NATURALLY **RUSTIC**

The Asian regard for natural materials, in particular bamboo and wood, coupled with the many regional country styles, makes rustic furniture particularly appealing. Using bamboo, cane, rattan and wood in a rough-hewn way taps into a particularly Asian aesthetic of simplicity and rejection of excessive decoration. For those who enjoy the Western modernist design principle of "form follows function," bamboo in particular has much to recommend it for furniture and even for construction. Left raw and unpainted, bamboo culms are immensely versatile for light and elegant constructions. Although found at various times in history throughout the region, it was in Japan that it reached its most profound expression with *wabi-sabi* and the tearooms of the great Zen master Sen no Rikyu, which in their use of rough materials—unhewn wood and mud—promoted modesty and humble surroundings. In fact, *wabi* (humble and simple) and *sabi* (rusted and weathered) come from an older Chinese Buddhist tradition. Far from being a poorer, make-do style of furniture and interiors in general, this Asian rusticity has maturity and purity, and it is no coincidence that probably the most highly regarded, and expensive, productions in this area are from the studio of a Japanese-American George Nakashima, featured below.

A simple living room in a house in Osaka was designed by architect Chitoshi Kihara in *sukiya* style, a tradition of unadorned simplicity, and furnished with table and chairs in chestnut by internationally acclaimed craftsman George Nakashima (1905–90).

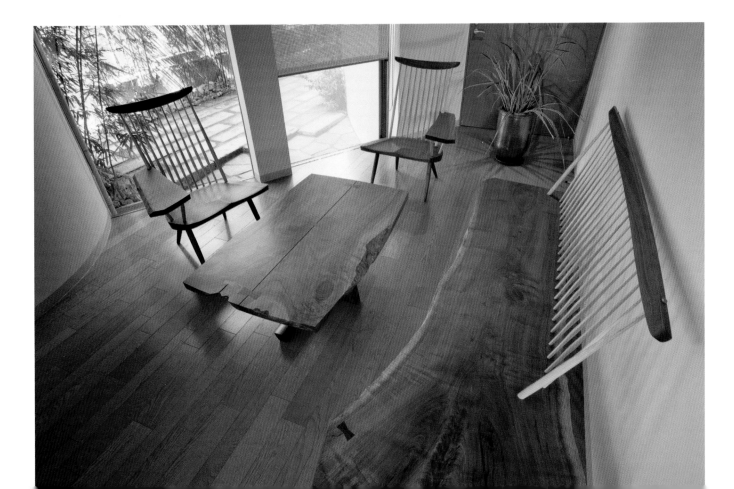

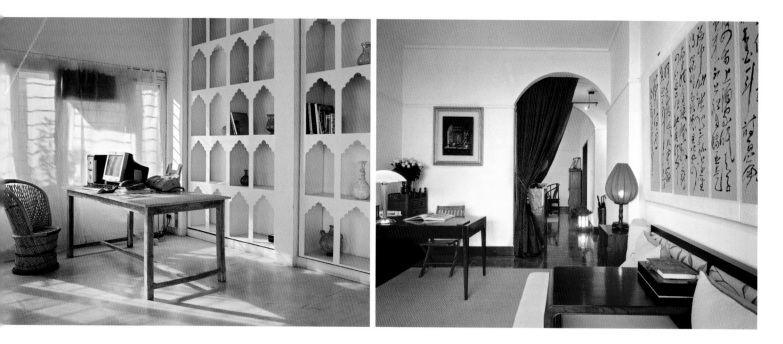

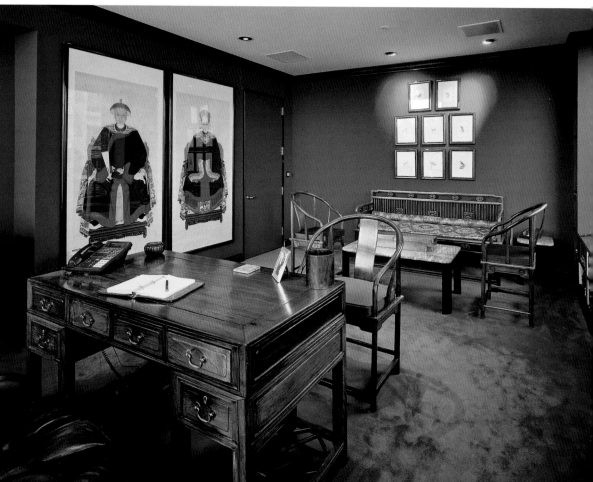

Above Jewelry designer Marie-Helene de Taillac created her own study in Jaipur with a simple imaginative display solution for the facing wall, reproducing the traditional Indian cusped arch in repetitive cut-outs.

Above right The study area of a converted 1930s apartment in downtown Shanghai features a deep sofa for use like a daybed, with a low central table reminiscent of those on opium beds. Ten calligraphy panels are on the wall above, while silk art deco lamps add color.

Right The deep turquoise of this office was chosen for walls and carpet to complement and set off the rich tones of the classic Ming desk and chairs made of *hongmu* a red hardwood.

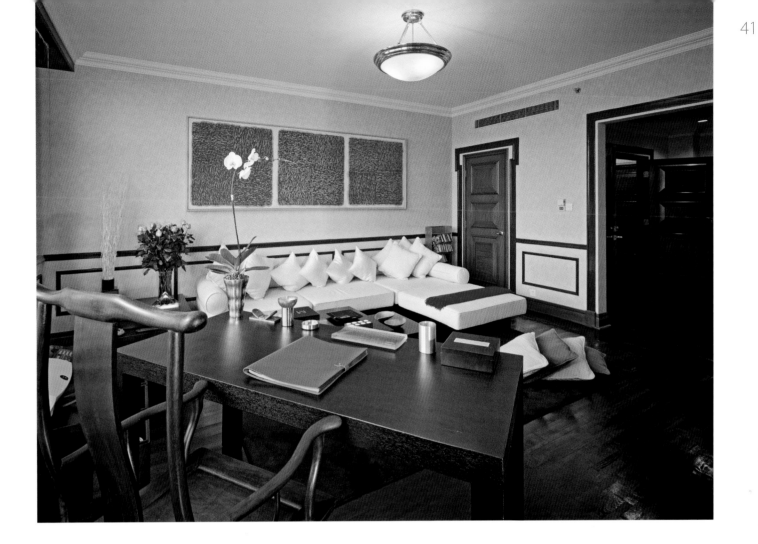

STUDIES **AND RETREATS**

The tradition of a private room conducive to study, thinking, reading and writing arguably comes most strongly from China, which then influenced other East Asian cultures. A scholar's study in imperial China was a meaningful retreat for any official or civil servant. The concept of men of letters—called *wen jen* in Mandarin, or as we would say, literati—was important in a Confucian upbringing, where poetry, calligraphy and painting were considered essential skills. The pace of modern life may have reduced these contemplative pursuits, but most people need a private space where they can work or engage in solitary pursuits, and the tradition of the scholar's study has evolved to furnish even modern needs. A well-sited desk and chair are essentials, with the room itself furnished and decorated according to individual taste rather than as display for visitors. Placing the desk in one corner, as in the Shanghai apartment below left, gives a full view and allows enjoyment of the decoration; the opposite idea, as in the Indian study opposite above left, is to face away and so aid concentration. Both work, and the difference is one of personality.

The study of another Shanghai property, an apartment in the 1930s Grosvenor House complex, adds a casual L-shaped sofa for relaxation. The yoke-back study chair is Ming, in the style known as "official's hat chair," because the line of the headrest resembles the hats of Ming mandarins.

Right The open structure of the Hardy House near Ubud, Bali, was inspired by Borneo longhouses, and uses undressed tree trunks for columns, so that the main living area becomes, in effect, a long central veranda.
Opposite above The upper floor of a converted farmhouse outside Jaipur, India, is shaded by a thatch roof supported by eucalyptus poles, which were salvaged from the replanting of the surrounding farmland.
Opposite below left A tiled veranda with Keralan wooden pillars supporting a roof extension, facing out onto a lawn, turns a simple cottage overlooking Lake Vembanad, near Cochin in southern India, into a lakeside retreat.
Opposite below right A version of a traditional Balinese thatch-roofed pavilion, or *bale*, perches on the edge of the steep slope of the Sayam Terraces, near Ubud. Slightly separate from the main house, this makes a perfect setting for an afternoon drink.

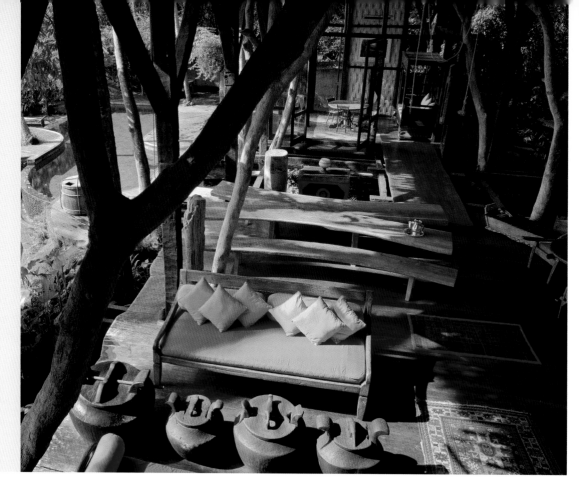

ON THE **VERANDA**

Projecting living spaces outwards in order to take advantage of the surroundings is another feature of tropical living, but also, as most of Asia is subject to hot summers, an attractive idea elsewhere. One principle that we already saw at work in living rooms specifically designed for the tropics, and which has a special place in much Asian architecture, is the way in which the interior of a house and the exterior are connected. The umbrella term used in English is veranda, but this embraces a variety of forms, all of which occupy an ambiguous position as spaces. The Japanese *engawa* is one: originally the term for the strip of wood surrounding a house, raised above ground level and sheltered by the projecting eaves, it now has a broader definition. Another is the Indian *barandah*. And everywhere the veranda is a space from which the outside can be enjoyed while still remaining within the house. Here and on the following pages is a varied range of interpretation, from a simple extension of the eaves to spaces that are enclosed on three sides, and even, as above, to a house that is entirely open on its two longer sides so that it is almost all veranda. Above all, verandas are places for relaxation and enjoyment, for sitting back and taking in the view; ideal for a quiet start to the day or for an evening drink as the daylight fades.

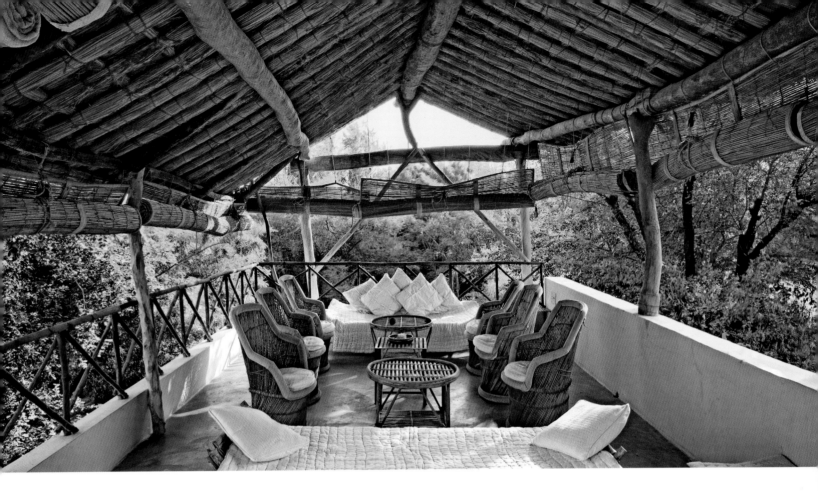

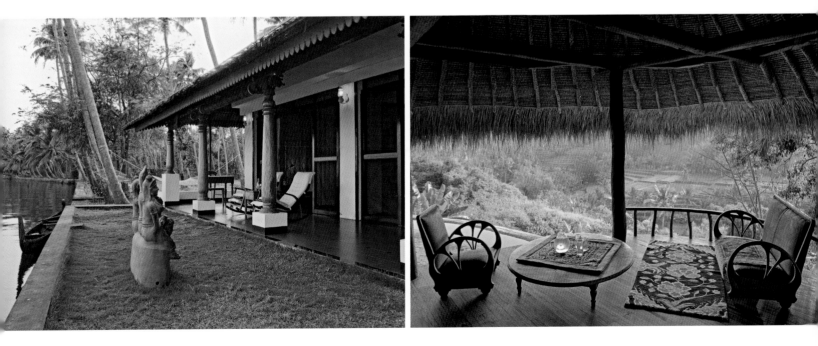

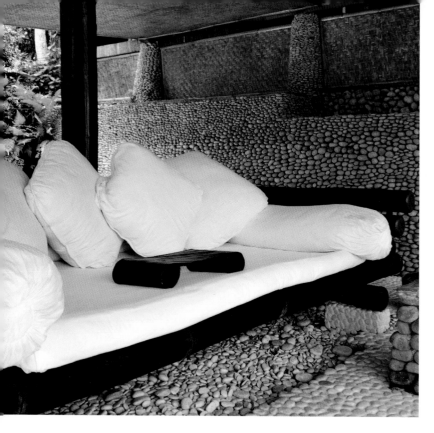

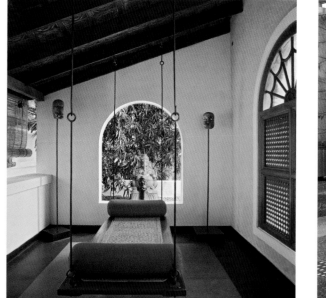

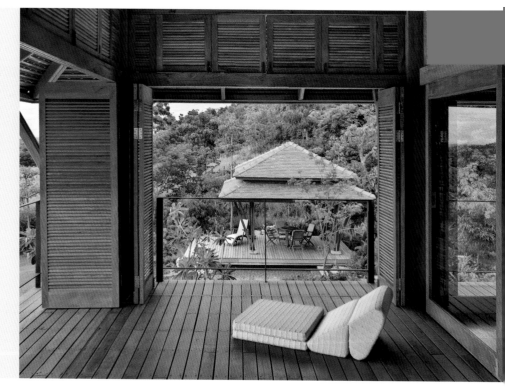

Above The steep valley slope of Linda Garland's Bali property near Ubud affords space under one of the guest houses for a sitting-out area, with walls and floor finished in closely packed pebbles.

Above right The Indian tradition of a swing hung from ceiling hooks makes a shaded daybed on the veranda of this converted colonial residency in Fort Cochin, Kerala. The primary colors keep the space vibrant in the tropical light.

Opposite above left A marine theme plays through this Indian beach house in Gujarat. The deep veranda, in concrete with a terrazzo floor inset with mirror fragments to catch the play of light, features two translucent blue pillars and porthole-like windows. Two wooden swings face each other across the space.

Opposite above right A veranda in local Jaipur red sandstone in the home of John and Faith Singh, with an upholstered recessed bench and a deck chair with armrests that extend to become leg rests.

Right In a contemporary version of a Thai house near Pattaya by architectural practice A49, folding slatted doors open fully on three sides to convert one room on the upper floor into a veranda, protected by an unobtrusive glass balcony.

Far right Two projecting wings enclose a large terrace area in the Gentry House, Bali, featuring decking and a pool. Massive and roughly dressed wooden pillars support the roof projection to make a shaded veranda.

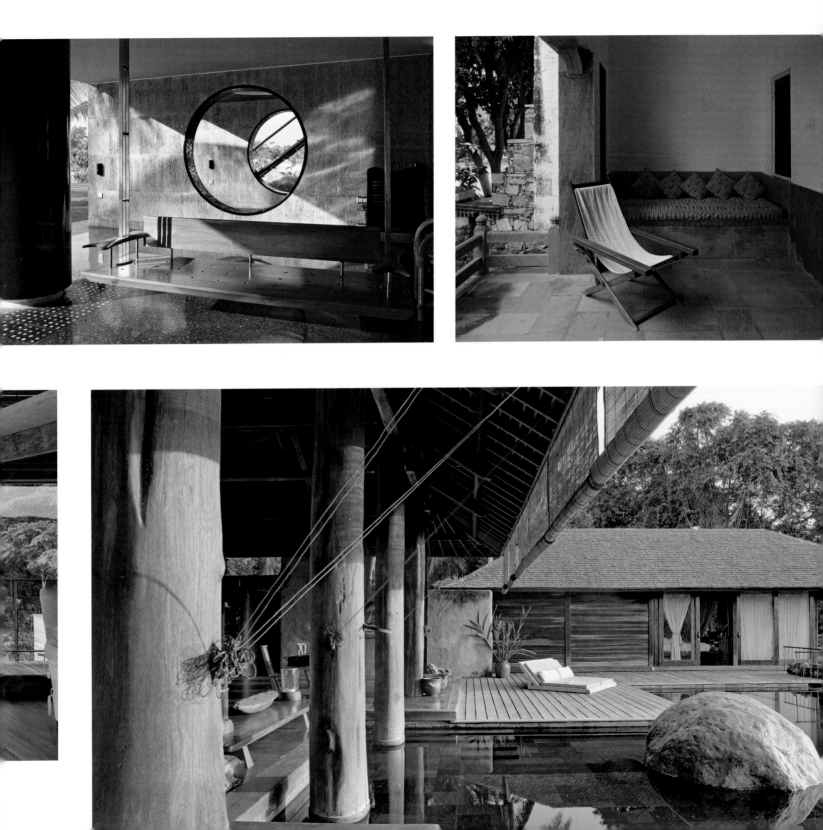

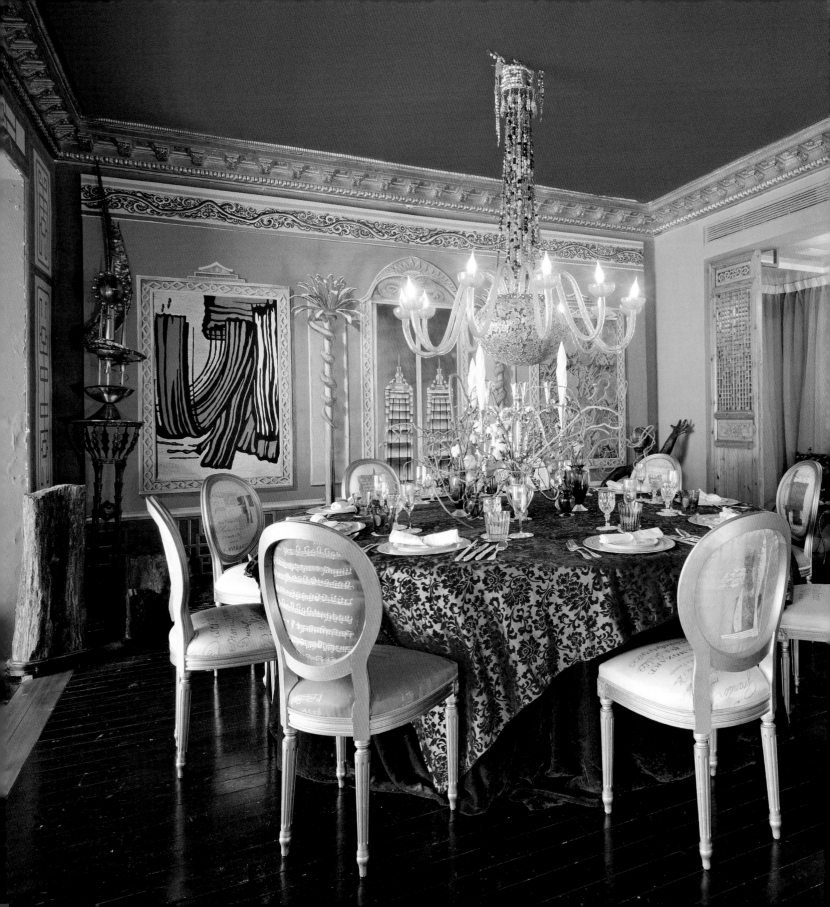

STYLISH ASIAN DINING ROOMS

Asian dining is, above all, communal, with a strong tradition of sharing and hospitality. This affects and pervades all aspects of the dining experience, from the way food is prepared and served to the layout of tables and even the style and decoration of the dining room. Add to this the different cultural directions, from India, Central Asia, China and East Asia, and tropical Southeast Asia, and you have a huge potential for variety in the design of the Asian dining room.

Meal times are important occasions to gather with family or friends, making the dining room the most convivial space in these homes. There is no single stylistic theme here, demonstrating how wide a range there is, from opulent to minimal and from retro to contemporary. There is, of course, a modern tendency to consider restraint and simplicity fashionable, particularly in design publications, but a true flair for design goes beyond the current.

Opulence and rich colors and textures have every bit as long a tradition in Asian culture as does plainness, and high Qing style and its modern derivatives are as possible and interesting as, say, the bare-bones quietness of Japanese *sukiya* style and its descendants. Pearl Lam's spectacular dining room design at left is a fully confident and inspired blending of Qing and European baroque extravagance that illustrates the value of truly individual taste as opposed to off-the-shelf Ikea borrowings.

We begin this chapter with formal dining arrangements. Formality is not, as some people believe, an outdated, uptight Western dining concept. Its expression in Chinese, Indian or Thai banquets, for example, is high entertainment, knowledgeably executed, and an excuse to pull out all the stops for guests. Following this, we look at cool simplicity, at casual and comfortable small family meals, and at that very Asian concept of low-level dining.

Opulence, an eclectic fusion of Asian and Western elements, and a sure touch with strong colors characterize this Hong Kong dining room by Pearl Lam. The "Emperor" chandelier design was inspired by a Qing headpiece.

THE FORMAL **ASIAN TABLE**

Formal dining is the occasion for making the grand statement, the opportunity to pull out all the stops and entertain guests in style. Of course, it needs the space, and the imagination, to suit, but if dinner parties are sufficiently important as part of lifestyle, then a dining room needs to follow at least some of the rules. Table shape is a first consideration. There is much to recommend a round table, and in particular the Chinese style with a rotating central section, because it allows maximum interaction between guests. However, round tables have their guest limit, at least outside of restaurants, because of size. For eight or more diners, a rectangular table is the practical choice. Place settings, which we will come to in greater detail at the end of this chapter, call for care and attention—and benefit from imagination, as the examples here show. And a formal dining room also needs to be a place for visual entertainment, hence the importance of the surrounding decoration.

The decorative elements in this small dining room include a late Qing panel inlaid with veined marble, flanked by two silver-framed mirrors and two altar tablets in *jichimu* (chicken wing wood).

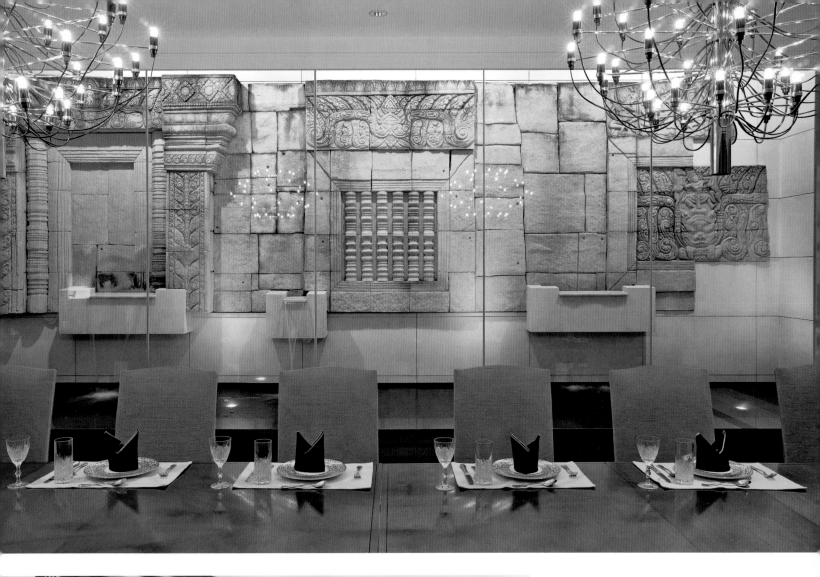

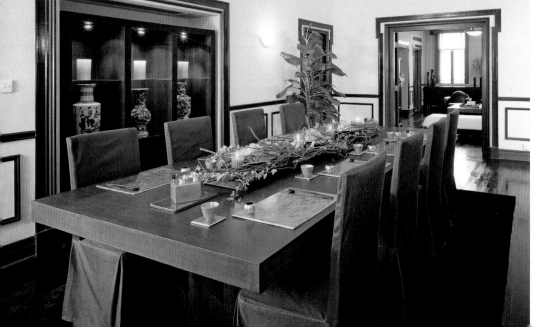

Above A full-length glass wall separates this Bangkok dining room from a lightwell with fountains, long pool and hand-carved reproductions of Khmer bas-reliefs from a temple in northeast Thailand.
Left The spacious proportions of a 1930s Shanghai apartment allow for a modern dining table in the form of a massive slab of wood that can seat eight or ten people. The alcove has been filled with three vases and, above them, three thick candles.

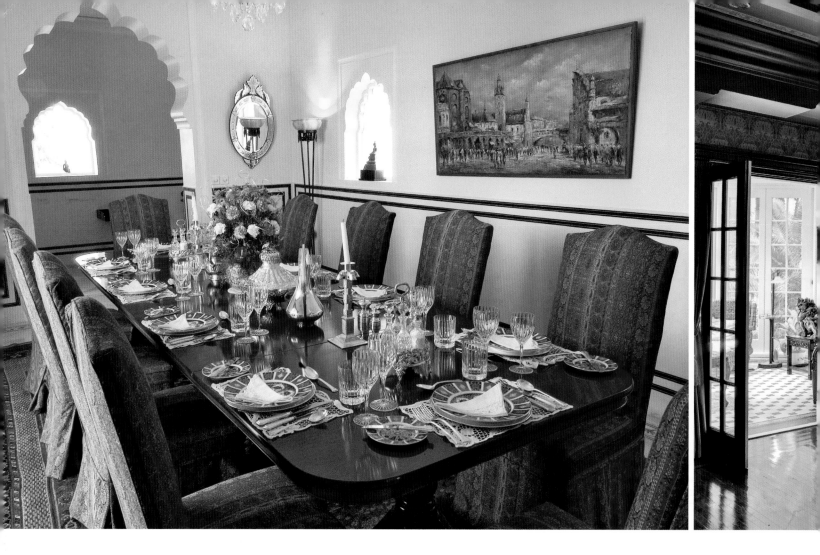

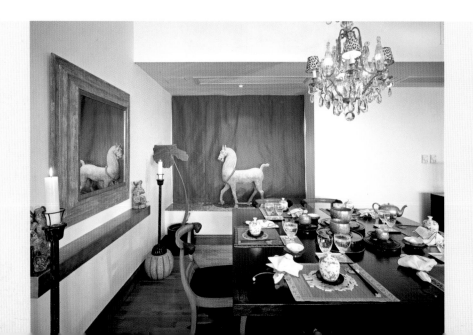

Above Blending Western and Indian styles, the main dining room of Naila Fort, Rajasthan, converted and designed by Mirjana Oberoi.

Left Carefully chosen Asian antiques transform table and dining room into a special occasion in the apartment of collector Louise Kou. Old jade pieces are used for placemats, chopstick stands and napkin holders; antique Chinese sugar bowls are used to serve soup; Burmese silver on black lacquerware forms the central display. A small window has been turned into an alcove with a red hanging, setting off the Tang dynasty horse.

Right A restored Qing dynasty lampshade dominates this art deco dining room in King Albert Apartments in the French Concession district of Shanghai. Six Ming yoke-back chairs add a sense of formality. The table is laid with Korean celadon ware.

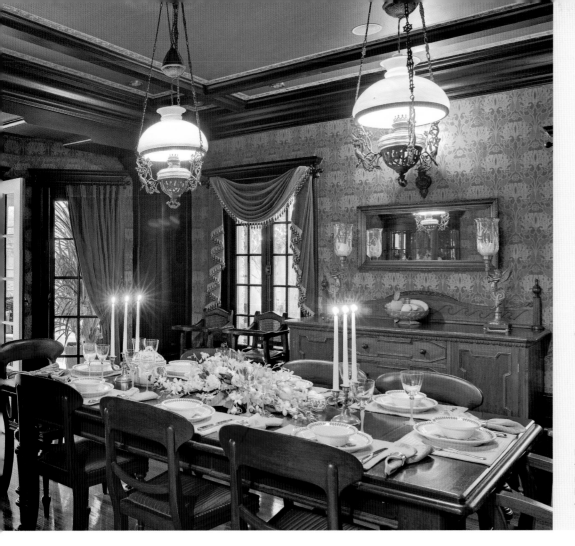

Left A candlelit dinner set in the wood-panelled dining room of a meticulously restored 1930s mansion in the French Concession Xuhui district of Shanghai.

Below In the same Rajasthani hilltop fort as the dining room opposite above, one of the round corner bastions has been converted into another dining room, its octagonal table set under a mosaic cupola.

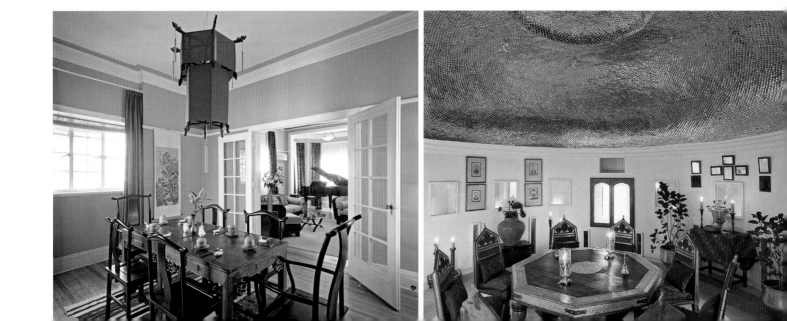

CONTEMPORARY **DINING**

The functional needs of a dining room might at first seem to work against being imaginative in designing this kind of interior. There has to be a table and chairs, and also space around for access, and this alone leaves less freedom for being original. However, as the examples here and on the following pages show, there are ways of exercising contemporary design. Asian contemporary remains strongly influenced by modernism, and so simplicity of line and color is common to all of the examples here. In these circumstances, where there is little in the way of unnecessary decoration to distract the eye, lighting plays a particularly important role: downlighters and uplighters play a part, lightwells for diffusing daylight, concealed lighting inspired by art deco principles. Contemporary interior design also lends itself to following a theme or idea, and among the original inspirations here are a gigantic curved window of Cinemascope proportions that slides open, clinical white enlivened by accented splashes of color and tone, and in one spectacular example, an all-glass dining room that merges with the surrounding water of a seaside setting. The best contemporary interior designers make a virtue out of the dining room's fixed functionality.

In a Hong Kong apartment, a circular dining table by Charles Rennie Mackintosh features a central section that rotates yet fits flush when not in use. Chairs upholstered in blue provide a complementary contrast to the warm wooden flooring. The blackboard behind is for the children.

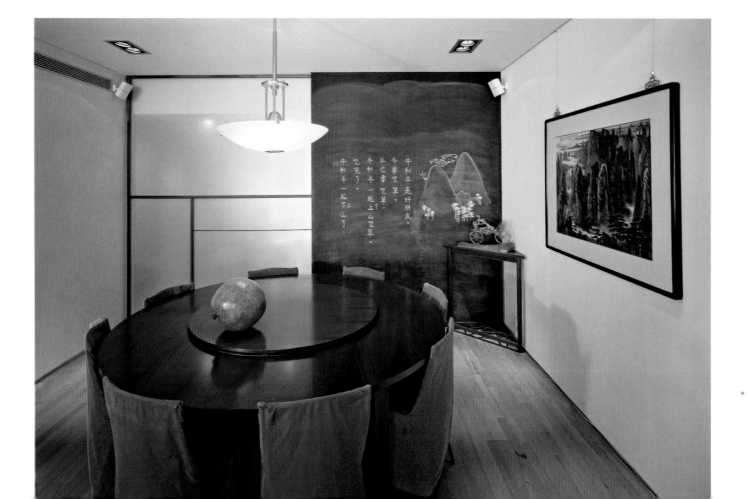

Right The geometric and simple lines of a square table in *wenge* wood with chairs by Christian Liaigre are offset by the curved wall in this contemporary Kowloon apartment. A low back-lit curved bench has been fitted to the wall.

Below An ordinary room transformed with simple touches: two Chinese silk table runners bring color and life to the dark wood table, while the originally unattractive window has been covered with Japanese-style paper sliding screens.

Below right The dining room of this unusual house in Tokyo, designed by Ken Yokogawa, occupies an extension fronted by a huge 4-meter-long curved window that slides open. A play of contrasting textures is set up between the wooden floor and furniture and the wall of raw concrete, which carries the impression of its wooden formwork.

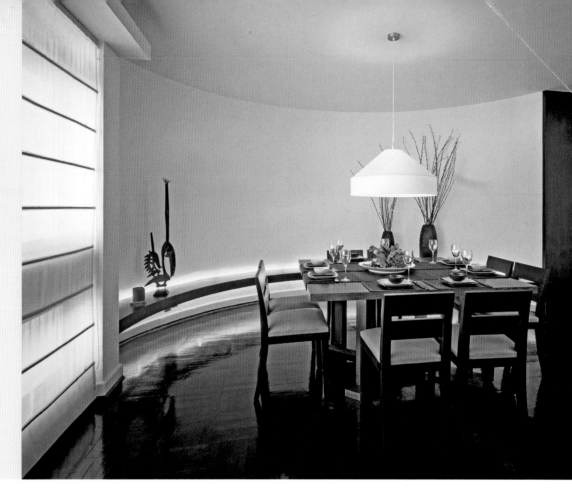

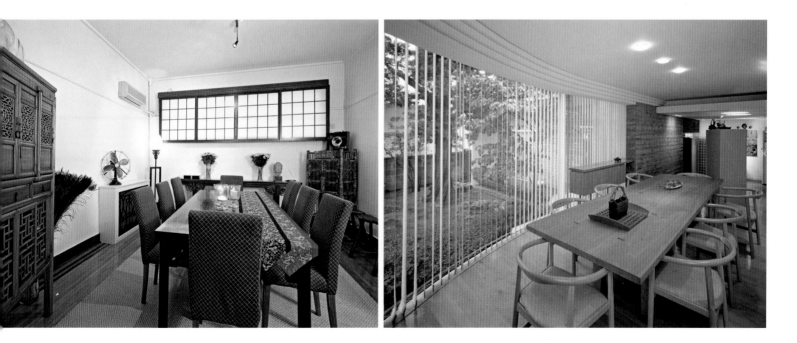

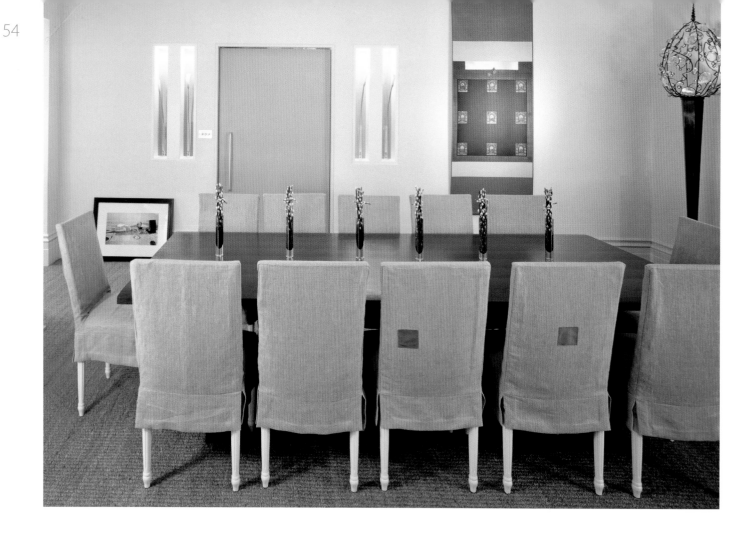

Above Muted colors and natural textures are the theme for this dining room by Kelly Hoppen. The door is framed by pairs of narrow vertical niches with downlight spots illuminating lilies in slim glass vases. **Right** A large statue of a black panther and a canine painting bring an exotic touch to this otherwise severely white dining room of an unusual contemporary house in Chiba Prefecture, Japan, designed by architect Norisada Maeda. Office chairs for dining are an idiosyncratic choice.

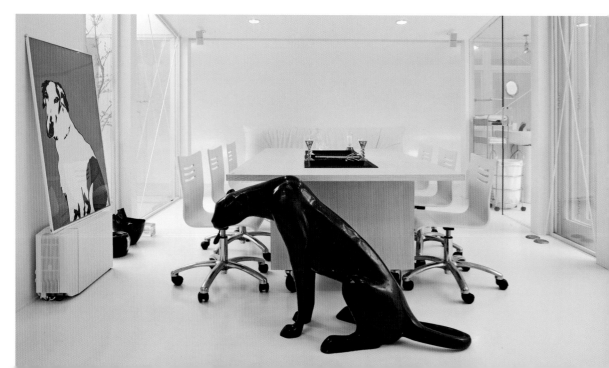

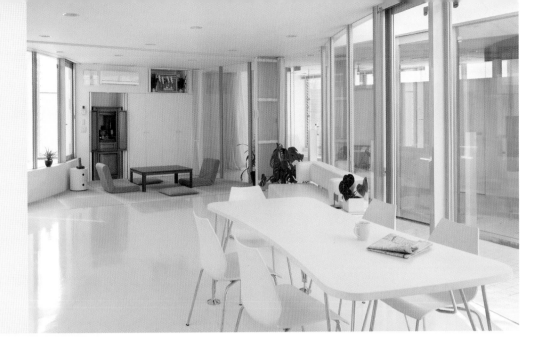

Right In a contemporary single-story Japanese house, designed also by Norisada Maeda, small courtyards provide illumination. The owners prefer a sparse and minimal style of living in white.

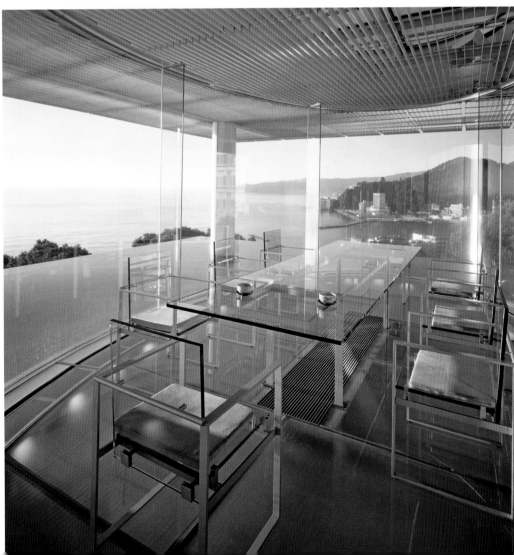

Left The spectacular and original oval glass dining room of Kengo Kuma's Water/Glass House in Atami, Japan. It sits as an island on a cantilevered extension amid an overflow pool that merges visually with the sea. The table and chairs are also in glass.

STYLISH ASIAN DINING ROOMS

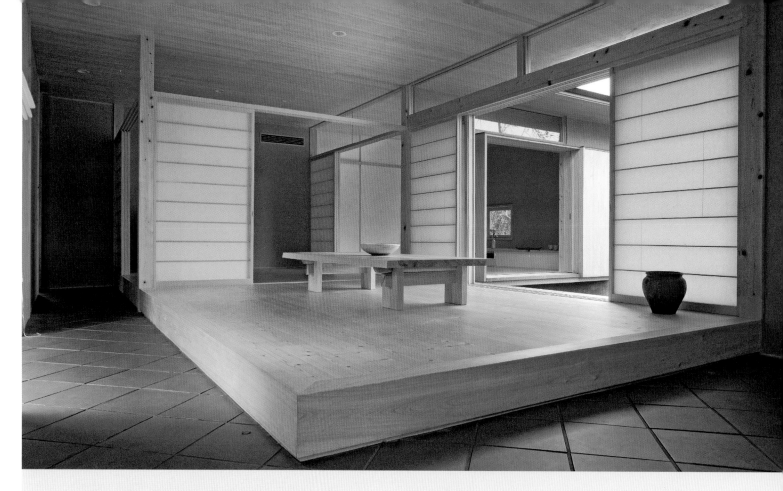

Above The central dining area of a house in Kyoto designed by architects Yumi Kori + Toshiya Endo of Studio Myu occupies a wooden platform to which guests step up from the slate-tiled floor. *Shoji* screens throughout the interior can be configured for any degree of openness or privacy.

Below In a weekend retreat in Kariat, north of Mumbai, architect Samira Rathod included an austere dining room, simply furnished with floor-level seating, facing onto a small interior court. One of the trees that was already on the site was left intact, and penetrates the roof.

Below In a dining room designed by Kengo Kuma in Tokyo, the theme is extreme and natural simplicity, with a cherrywood table set against a wall covered with handmade *washi* paper. The floor cushions are also covered in handmade paper with a protective coating.

LOW LEVEL **DINING**

Most Asian cultures have within them some tradition of eating close to floor level—from a low table and without chairs. While the origins of eating while seated on the floor are undoubtedly humble, this style of eating has historically been recognized as both elegant and proper. One of the design advantages of dining in this traditional style is that it allows for a simple and even modernist space, uncluttered by chairs and without the height of a normal table occupying volume. For comfort, small cushions can be used, such as the Japanese TK. One thing that floor seating makes essential is not only that it be kept spotlessly clean, but that shoes are never used. Removing shoes when entering a living space is, in any case, a long-established tradition throughout Asia. It is worth mentioning that low-level dining absolutely does not work with a Western cover of knife and fork, on purely practical grounds, as two-handed eating demands facing the dish square on, at a certain height and sufficiently close that the knees have to be under the table, which makes the table high. Low-level dining is one-handed dining, suited naturally to chopsticks and, even more naturally, to eating by hand (which is possibly ancestral to chopsticks).

Above right A section of tree trunk left with unworked edges and a wall of hand-picked granite stones and boulders make this *tatami* room a study in natural textures.
Center Typical country-style low stools and low table furnish the dining room very simply in this farmhouse outside Jaipur, converted by Munnu Kasliwal.
Right A modern version of a *tatami* room in a Tokyo house designed by Yasuo Kondo features a plain low table and frosted glass sliding doors.

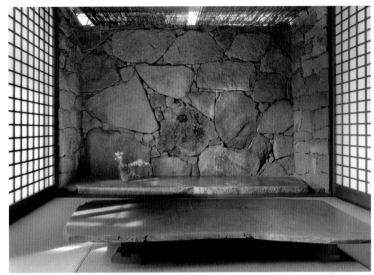

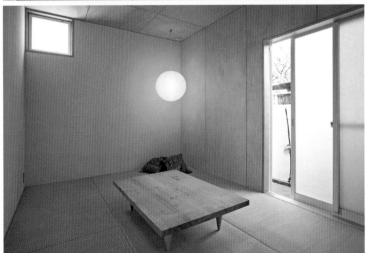

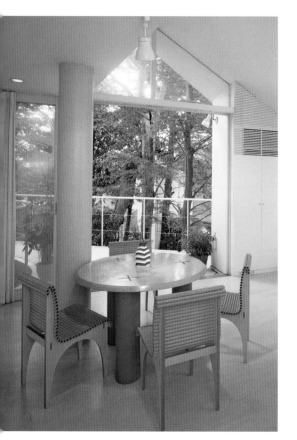

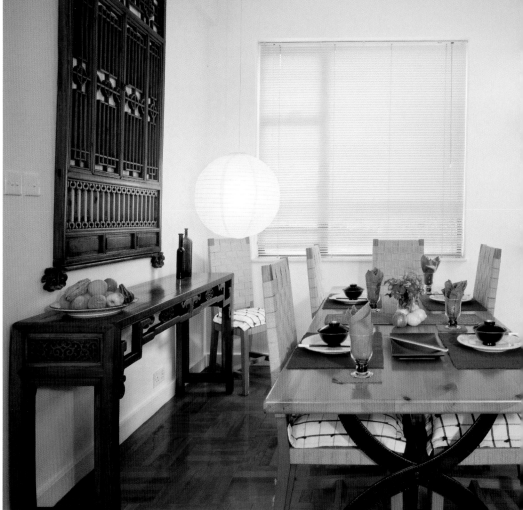

Above In the dining room of leading Japanese architect Shigeru Ban, the chairs are made from his trademark material—cardboard tubing.

Right In a New Delhi apartment, high-backed chairs in stained woven bamboo strips surround a massive glass-topped table in tropical hardwood.

Far right A simple dining room used by owners and staff in the converted courtyard house of Jehanne de Biolley, close to central Beijing's Drum Tower.

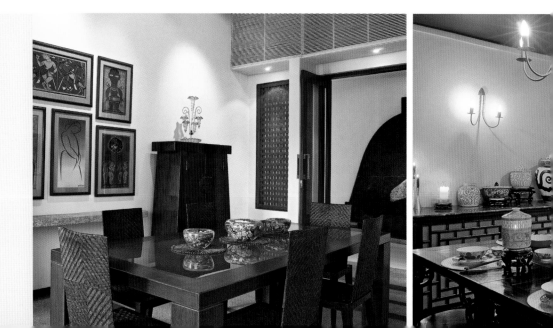

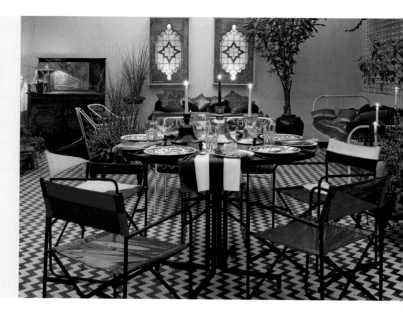

Left In a small ground-floor Hong Kong apartment, the unremarkable space assigned to dining is given presence by the addition of three Chinese pieces: a long, narrow altar table, a carved openwork door panel hung as a display, and facing it, a calligraphy scroll mounted on a red-painted wall.
Right In an apartment in one of New Delhi's colonies, high walls convert the chevron-tiled terrace into a courtyard for dining and entertaining.

FAMILY **CASUAL**

Formal dining apart, all homes need a place reserved for ordinary family meals. These being both integral and integrating occasions in home life, there is every reason for creating a comfortable and convenient space for them. This is a value that has been prevalent for a much longer time in Asia than in the West, and skimping on normal meals is not an option.

Ceremony is unimportant, in contrast to the formal dining rooms shown earlier, and there is more room for individual preference. The table size can be modest and materials simple (for a notable exercise in economy, look at the furniture in renowned Japanese architect Shigeru Ban's own home—cardboard tubing, a material he has made very much his own, even structurally for buildings!). The kitchen, if large enough, is also a suitable place to consider putting the family dining table, as shown left and overleaf (there is a long tradition in parts of Asia of the entire family, including staff, dining together).

Decoration is often personal and simple. As the Western owners of the dining space in the largest picture here (above left) point out, a few well-chosen pieces "can lift a nondescript environment, sit well in a contemporary setting or enrich even a cluttered one."

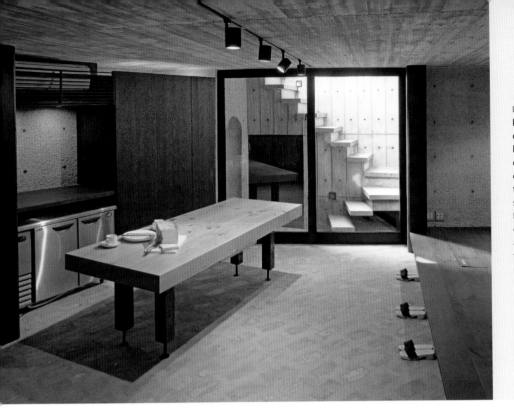

Left A massive block of wood in the basement kitchen-cum-dining room of this Tokyo house designed by Michimasa Kawaguchi serves for both food preparation and eating. The diagonally laid old stone bricks and the concrete ceiling with timber formwork make a strong textural contrast. When not in use, seating is stored in cupboards

Below Four Ming *huanghuali* horseshoe-back chairs surround a simple rectangular table in an even simpler room in white with travertine floor. Other than the cabinet, there is no decoration in a space intended for home dining rather than entertaining.

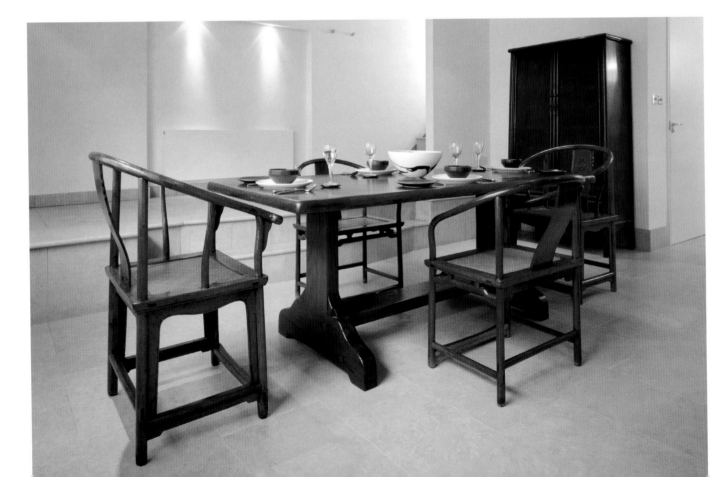

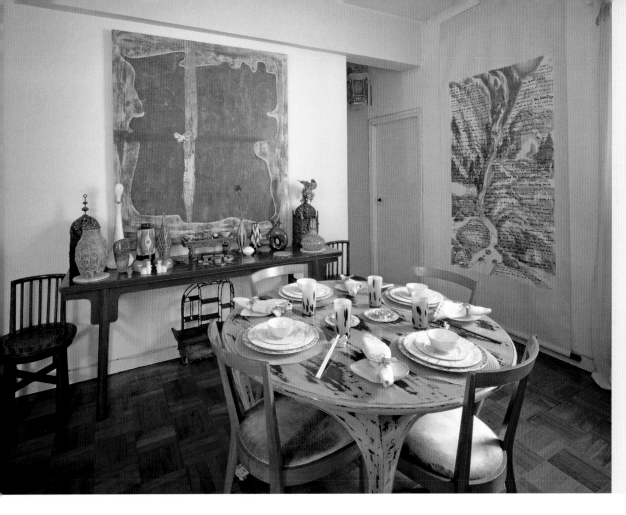

Left The table in this family setting has been lacquered and then scraped for a distressed look. Chairs are by Gio Ponti, and the decor is completed by two paintings and a Chinese side table.

Below left Suede-covered cherrywood chairs surround a table with frosted glass top, walnut veneer rim and steel frame, designed by the owner Alec Stuart for his Hong Kong apartment. A painted Tibetan chest stands against a deep blue-painted wall.

Below Natural textures and materials carry the theme in this Tokyo dining room, with table and chairs by George Nakashima, a wooden floor stained with *sumi* ink, and wall covered in *washi* handmade Japanese paper.

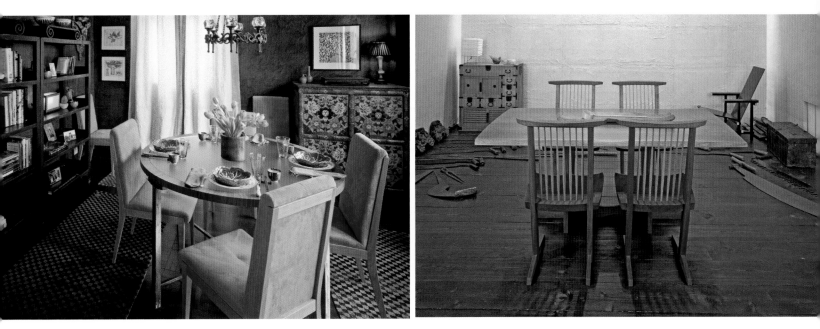

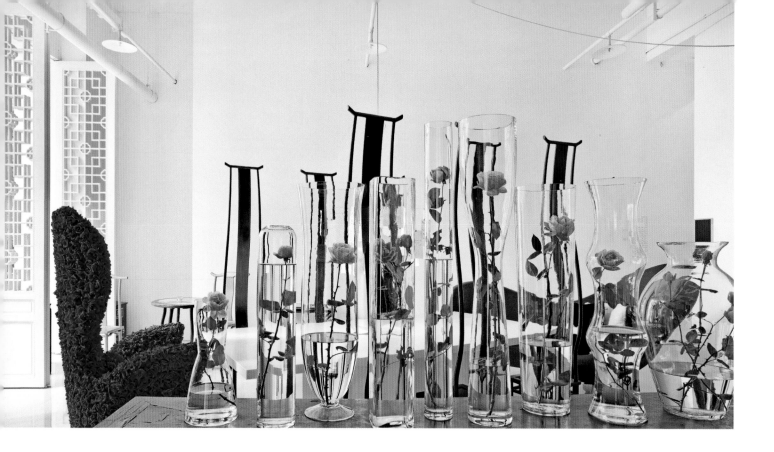

DINING WITH **FLOWERS**

Flowers offer an ever-changing, good-value and always wonderful source of decoration and delight for a dining table, and by no means need to be reserved for special occasions. Their freshness and color are a perfect complement to food, mirroring the seasonality of dishes.

In the Japanese formal *kaiseki* tradition, floral arrangements are chosen with extreme care and stress the season—fresh cherry blossoms, of course, at the time of *hanami* (cherry-blossom viewing), and russet tones, including maple leaves, for the autumn. For winter, you could bring fresh flowers as an antidote to the season, or follow it with dried flowers. The vases or other containers deserve some thought, and their dimensions and proportions should match the table.

A circular table, such as in the Chinese style, suggests a container and arrangement that is focused and central, while a long table calls for either a linear arrangement or a series of two or more. Two of the examples here follow this style, one simply a selection of interestingly shaped tall glass vases, the other a flexible chain of cylinders, and in both cases perfect for individual long-stemmed blooms. Glass, incidentally, has the advantage on a table of connecting opposite sides rather than creating a barrier, an important consideration if your flowers are relatively tall.

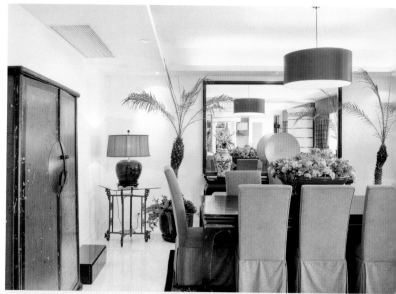

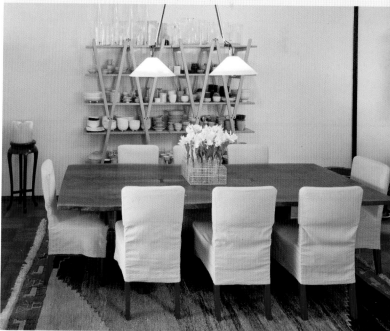

Above A shallow red-lacquered basket fulfills the role of a cornucopia, brimming over with an arrangement of fruit and flowers, in the dining room of this Shanghai apartment. Two potted palms flank the large wall mirror.
Below A cubic vase made from test tubes set in a metal box contains ginger flowers, illuminated by suspended industrial-style lighting.

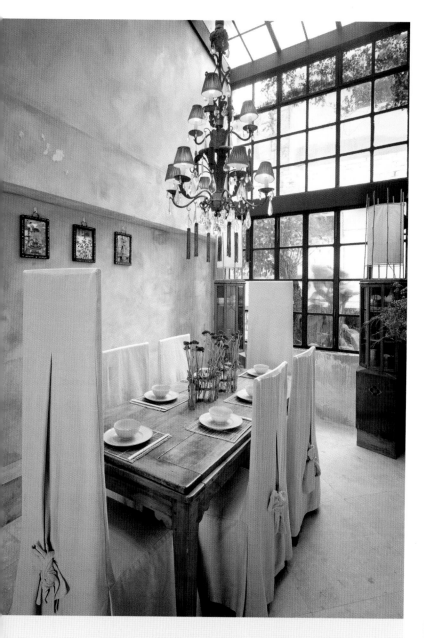

Opposite Single roses in a row of individually blown tall thin vases distort the exaggerated curves of the theatrically high-backed Ming-inspired chairs in Beijing's Green T. House.
Above A chain of slim glass cylinders hold the central floral display of red peonies in this Hong Kong dining room, with distressed walls and ceiling.

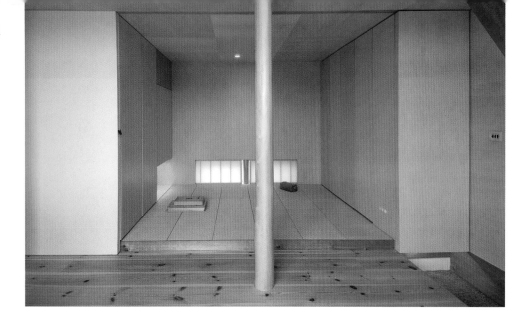

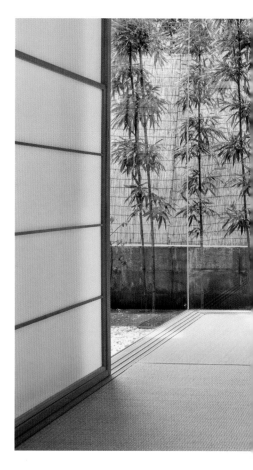

TATAMI **SIMPLICITY**

The Japanese *tatami* room, as most people call it, is a special case. It is unique not just in an Asian context but among all domestic interiors. Endowed with its Zen-like qualities of emptiness, plainness and simplicity, it is the only formally defined dwelling space that is non-utilitarian. Other rooms have a purpose connected to living, be it living, eating, sleeping, washing and so on. The *tatami* room is entirely conceptual. And yet, in its less "pure" form, it can be an exquisite space for occasional dining. The Japanese recognize two kinds of such room, the *chashitsu* and the *washitsu*, though both may be physically similar. As *chashitsu*, it is reserved for the tea ceremony, but as *washitsu* it can have more casual use. In any case, the full tea ceremony, or *chaji*, involves food in the form of a light meal, or *kaiseki*, during the first "act" of the ceremony, so eating light dishes is entirely appropriate. The basis of the space is, of course, the *tatami* mats which, with their *igusa* straw component CK, proved a firm but yielding surface for sitting. The standard size of a *tatami* mat varies by region, but in Tokyo is 20 ft x 58 ft (880 cm x 1760 cm), the area occupied comfortably by a sleeping person. Six *tatami* and eight *tatami* size rooms are most common. Traditionally, the entire structure is of light-weight materials, with sliding *shoji* screens made of light wood frames across which is stretched handmade *washi* paper. Such a room is, naturally, a commitment of space and considerable effort, but the result is a very special, calming and reflective space perfectly suited to delicate dining.

Top A slightly raised small *tatami* room is flanked by plain-fronted white storage cupboards. Two wooden pillars, half-dressed from small pine trunks, support the mezzanine above.
Right This large eight-*tatami* mat room in Kansai, designed by Chitoshi Kihara, is located below the main living floor. The calligraphy is by Ryokan, a highly regarded Zen priest of the Edo era.
Center right In an open-plan design for a Kyoto house by Jun Tamaki, the *tatami* floor space is kept free of furniture, and the thick walls allow geometric shapes to be "carved" out of them in the architect's concept of negative space.

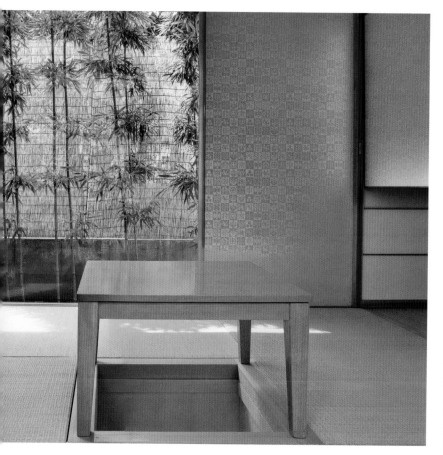

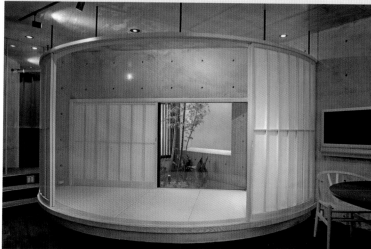

Left Projecting into the small garden of this Tokyo house, this *tatami* room has sliding *fusuma* doors and *shoji* screens which open to reveal a stand of bamboo.

Below An unusual semicircular version of a *tatami* room designed by architect Michimasa Kawaguchi mediates the space between the living room and small balcony garden in a Tokyo apartment. The sliding screens control which way the room "faces."

Bottom The innovative feature of this contemporary *tatami* room by Ken Yokogawa is the use of pegboard covered with handmade *tosa-washi* paper for the wall and ceiling.

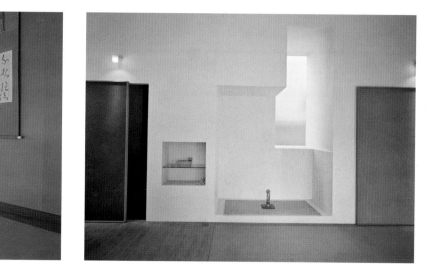

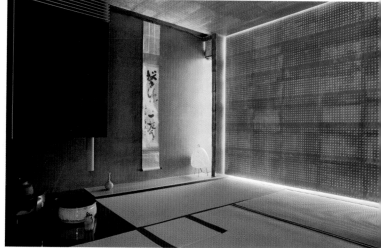

STYLISH ASIAN DINING ROOMS

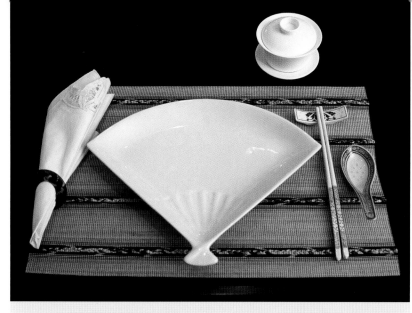

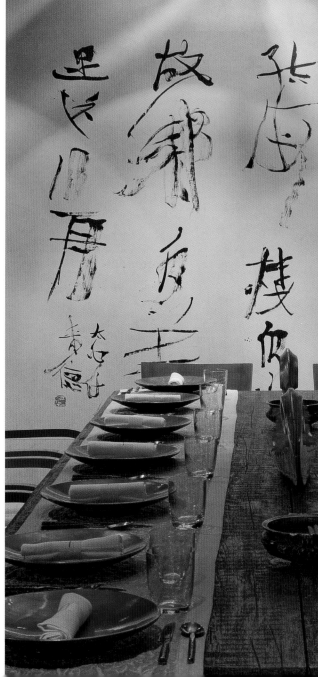

Above Simple yet elegant, a fan-shaped white ceramic underplate sits on a bamboo placemat. **Right** An unusual and striking design for this dining room, with a table that can seat up to sixteen, is a wall covered in calligraphy—a Chinese poem.

ASIAN TABLE SETTING **IDEAS**

With several different regional styles of eating, the Asian table offers a particularly wide variety of ways to present food. Throughout East Asia and urban Southeast Asia, the Chinese style of chopsticks and bowls dominates. Both Korean and Japanese are variations of this, the former using a long-handled shallow metal spoon and favoring silver chopsticks, the latter using smaller wood chopsticks, sometimes disposable for hygiene reasons. Traditionally, an individual place setting for a Chinese-style meal comprises chopsticks, a flat-bottomed ceramic soup spoon and a bowl and small plate, with food taken from central communal dishes and bowls. Make sure that each person has access to all of them. The standard circular table with a revolving central section on which the dishes are placed is ideal, but if you have a longer rectangular table and a number of guests, it will be more convenient to have two serving dishes for each item of food. The individual bowl is used for soup and also for rice (if being served) as a base to rest morsels picked up with the chopsticks. The small plate can be used for resting a piece of food which is too large to be eaten in one mouthful, and also for depositing bones (most meat is cooked on the bone for flavor and cut into small pieces). With relatively small eating dishes (bowl and small plate), the individual place setting assumes importance, and both placemats and underplates are an opportunity for displaying imagination, as in the examples here. Chopsticks need a rest, and at formal dinners the soup spoon also.

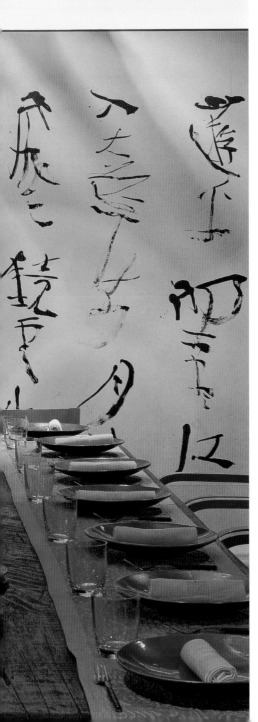

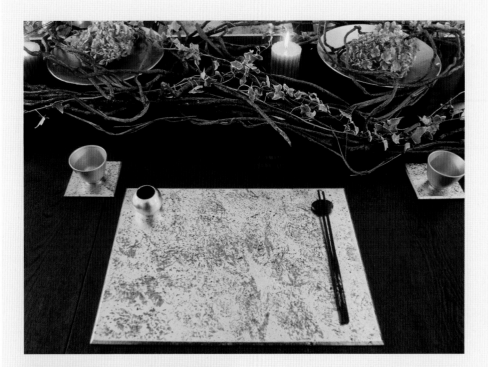

Top Gold-lacquered place settings and gilded cups add a touch of opulence to this dining table in a Shanghai apartment. They also harmonize perfectly with the color-coordinated table decoration.

Above left and right A delicate idea for this Japanese table is an exquisite inlay of a maple leaf set in one corner. White porcelain tableware is by TK and the peacock feather-designed placemat by Pearl Lam.

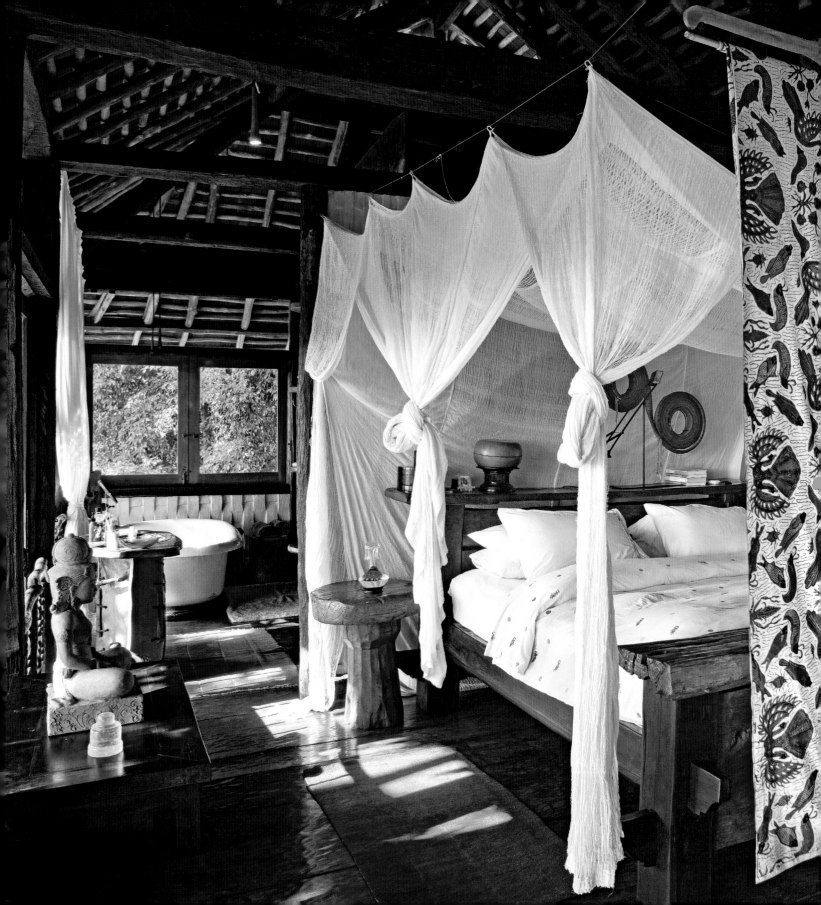

ASIAN BEDROOMS AND BATHROOMS

Bedrooms and bathrooms in Asia have been going through a revolutionary design makeover in the last two decades as their place in the hierarchy of rooms has risen. In the contemporary homes featured here, they are less utilitarian and more integrated into the overall lifestyle. More time is spent in both simply enjoying and relaxing and, therefore, many more ideas have been poured into them. The result is remarkable variety as a range of influences are drawn together and made to interact. One is tradition, which has proved to be a rich source. For bedrooms, this includes the concept of the room within a room, exemplified by the Chinese canopy bed, but also in practice by the wide use of mosquito netting in tropical Asia, while the Western counterpart, the four-poster, blends well into the same style of use (and in one example here, Chinese canopy and Western four-poster have been successfully merged). Tradition also draws on the uniquely Japanese style of flexible floor sleeping on *tatami* mats, and on the range of bed platforms from other countries in Southeast Asia and the Indian subcontinent.

The traditional component in bathrooms comes principally from Japan, which once again has a unique *ofuro* bathing culture (based on relaxation and so perfectly suited to the new pleasure principle for bathrooms) and from nineteenth-century Western ideas. Another major influence is Western contemporary, with its roots in modernism. Cleanness of line, simplicity of color and brightness have not only endured and prospered as design principles internationally but have melded particularly well with certain aspects of Asian style, including Ming-period ideas from China, Japanese naturalism by way of *sukiya* style, and even the clean rustic functionalism exhibited in the widespread use of bamboo.

Jewelry designer John Hardy made his own bed for his Bali residence out of old teak and ironwood slabs, with muslin used for straining tofu as the mosquito netting.

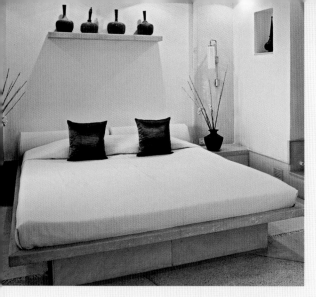

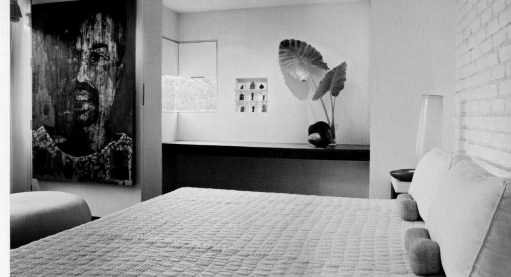

Above The bed in this converted old Rajasthani fort near Udaipur is formed from a marble plinth. Downlighters illuminate a row of antique local vases displayed on a high shelf.
Below left Mixing interior and exterior in a contemporary Balinese home, architect Ian Chee created a courtyard garden to extend this bedroom.

Above White marble has been used here in an angular sculptural design by Rajiv Saini, featuring a sloping basin and a backlit recess for displaying figurines.
Below right A framed screen made of split bamboo, attached to the ceiling, partitions this simple Chinese bedroom near Hangzhou, which is minimally decorated.

Opposite above Designed by Kengo Kuma for the penthouse guest suite of a lighting company in Shanghai, this room features an electrically operated louvered ceiling to control the daylight and a cantilevered wooden plinth for the bed.
Opposite below Concealed lighting and a warm, restrained color palette impart a sense of calm luxury to this bedroom in a new Pudong villa development in China, designed by studio CL3.

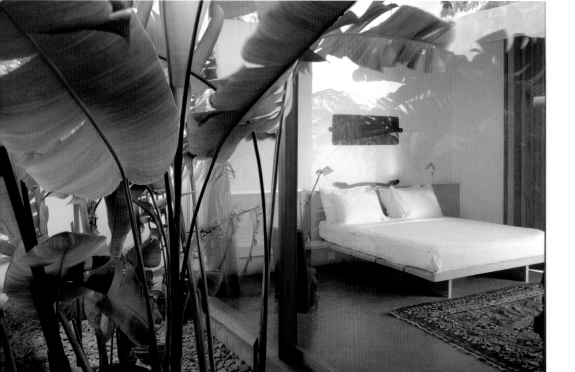

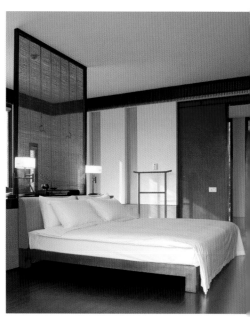

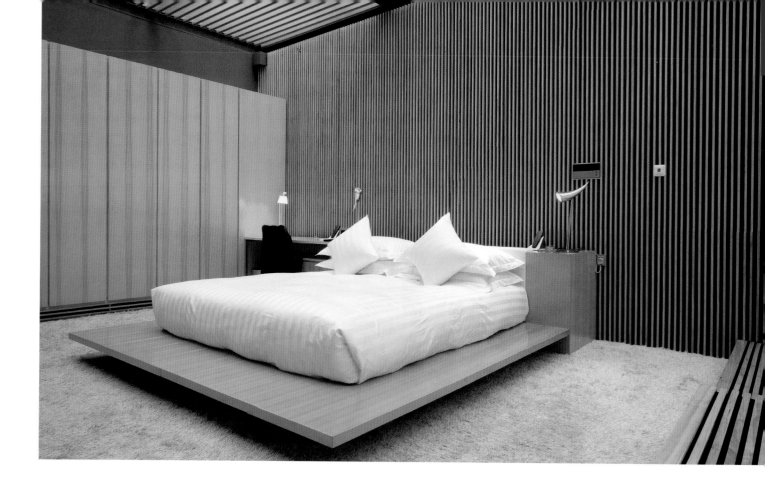

COOL CONTEMPORARY

In this style, the bed itself is stripped of decoration and instead is left plain, simple, white and spacious. The bed frame, too, is simple and functional in design. Wood in a natural un-painted finish is a favorite, although Rajiv Saini in India makes use of the abundance of in-expensive stone in the north to fashion a bed out of white marble. Two of the designs here use a plinth, with the main surface overhanging the base support to give an impression of floating. In these cool, understated modern bedrooms, decoration and color have given way to space and light, and the dominant surfaces are white and natural. White is fully receptive to well-designed lighting, both natural and artificial. In the bedroom for a Shanghai penthouse, above, architect Kengo Kuma fitted louvered panels across the entire ceiling, under glass. Elec-trically operated, they can alter the distribution of light at a touch. Elsewhere, downlighters and concealed lighting for shelving and headboards give both warmth and precision. Natural wood adds warmth without pretension, and in the case of the one tropical bedroom here, at left, architect Ian Chee connects the sleeping space with the green of a planted courtyard.

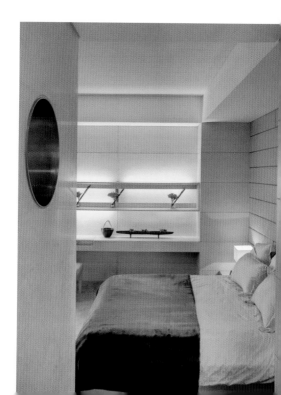

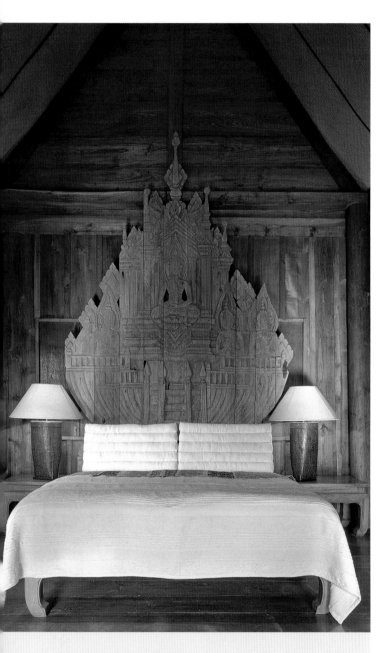

TOUCHES OF
TRADITION

Traditional beds and styles throughout Asia are a rich source of inspiration, from all periods, including colonial and Western-influenced. They can be antique pieces, reproductions or even adaptations, as in one or two examples here, taking the traditional form as inspiration for a contemporary take. Given that the basic structure of a bed is simply a platform, traditional forms are very easy to adapt by adding a modern, comfortable mattress or *futon*. Indeed, the platform structure of Thai beds, for example, is identical to that for low tables and the pieces are traditionally interchangeable.

The Chinese canopy bed is the most distinctive of all places for sleeping, and is in effect a miniature room within a room—even a building within a building. This enclosed and very private space can nevertheless be opened during the day (and in Chinese tradition, really did function as a daybed). It bears, of course, more than a passing resemblance to a Western four-poster bed, but while both were intended to be fitted with fabric curtains, the Chinese canopy bed is more substantial structurally, and the various panels are the canvas for carved scenes or floral decoration, either in bas-relief or openwork.

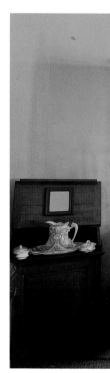

Above A converted old teak house in Mae Rim, Chiangmai, features a traditional Thai bed/table with inward-curving legs and a headboard in the form of a wooden pediment salvaged from a rebuilt temple.
Opposite below left Draped with mosquito netting, a brass four-poster bed graces one of Malacca's renowned Peranakan houses, built in the late nineteenth century for a Straits Chinese family.

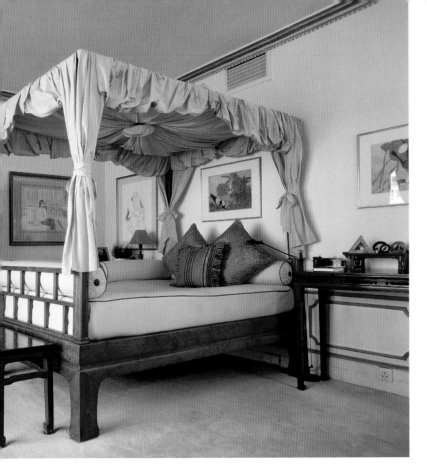

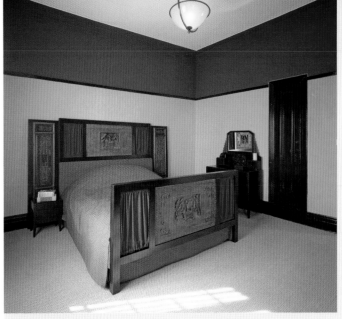

Left A Ming canopy bed made to resemble a Western four-poster, with pink fabric around the posts and canopy, including its ceiling, complemented by a cream mattress and bolsters.

Above This beautifully restored Shanghai art deco bedroom in King Albert Apartments features a modern bed inset with Qing-dynasty carved wooden panels, the headboard flanked by early twentieth-century panels.

Below A newly built bed with a period feel for an old planter's house in Kerala, India. Antique pillars support the platform, while the headboard is formed from an old window in which the glass has been replaced with mirrors.

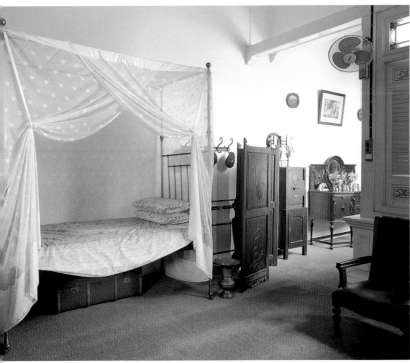

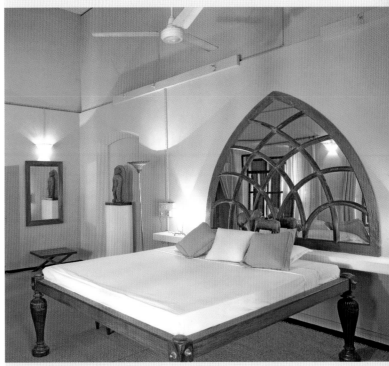

ASIAN BEDROOMS AND BATHROOMS

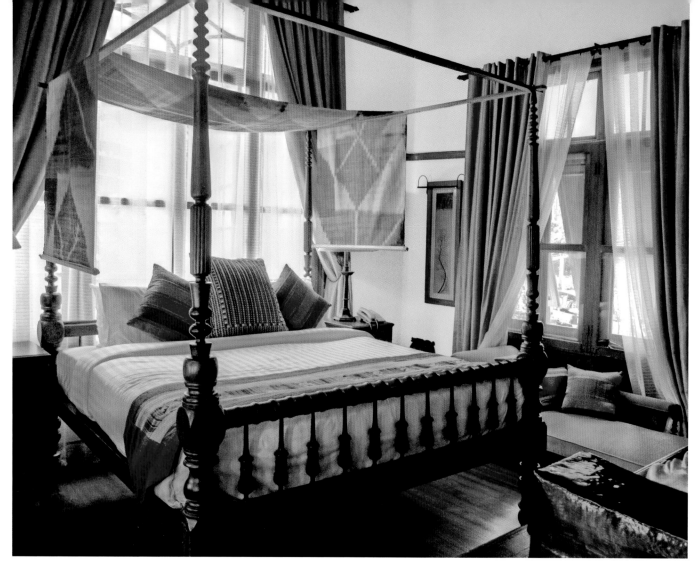

Above In a lovingly maintained 1940s Thai heritage house, Ariyasom Villa, in Bangkok, period furnishings include a turned wood four-poster.
Right A Keralan bedroom in Fort Cochin combines antique elements—old Keralan pillars for the bed and a wooden headboard from a chariot—with vibrant colors on the walls.

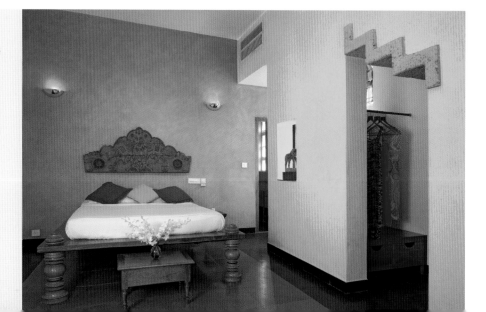

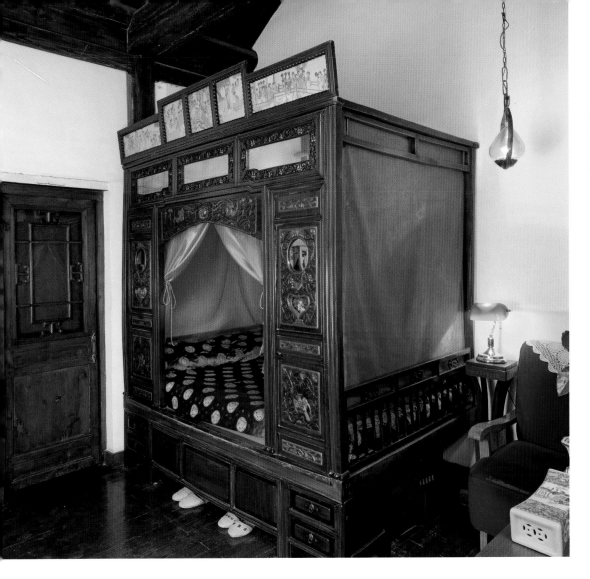

Left An elaborately decorated Qing-dynasty canopy bed in an old Beijing *hutong* house is made even more opulent with purple silk bed and pillow covers and peach-colored silk curtains.

Below left Classical Chinese elements—a small *kang* table in *huanghuali* wood, a seventeenth-century folding stool with built-in footrest, and a pair of silk embroideries on the wall—combine with a contemporary bed in strongly grained wood and an Anatolian carpet hung above the bed.

Below The bedroom of a traditional central Thai teak house near Nakon Pathom. The low bed design with incurved legs also doubles in Thai furniture design as a table. Note the inward-leaning pillars and walls.

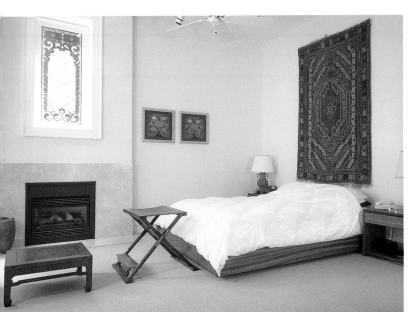

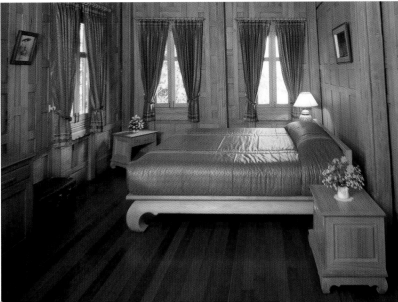

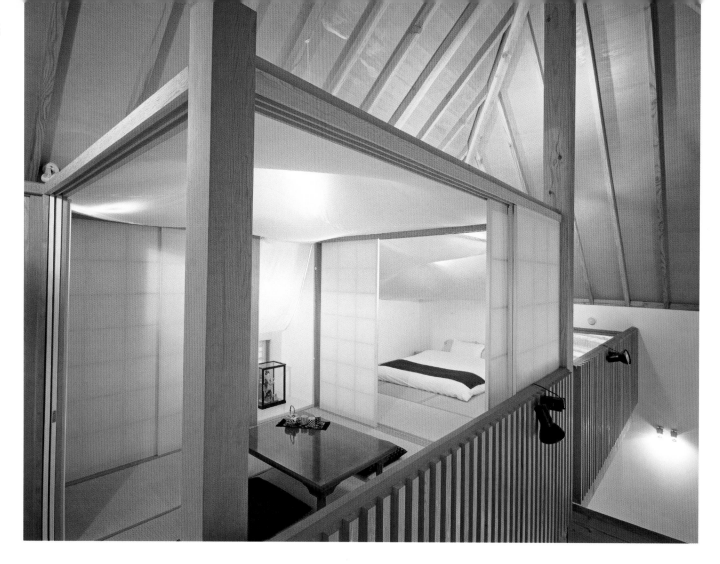

JAPANESE STYLE **SLEEPING**

Traditionally, floor-level sleeping was common throughout Asia, but it persisted longer in Japan than elsewhere, largely due to the invention of *tatam*i, the solid mats that during the Muromachi period became complete floor covering. *Tatami* mats, which come in regulated sizes that are all approximately the space needed by one person lying down, quietly revolutionized the way of living as they spread down through the social strata by creating a clean, comfortable and enjoyable surface for sitting and lying, without the connotations of dirt and dust that a floor normally has. The covering is woven soft rush straw and the core is traditionally rice straw, but nowadays commonly compressed wooden chips or polystyrene. *Tatami* mats have a certain "give" and so themselves make a good and healthy surface for sleeping with the addition of a light mattress, known in Japanese as a *futon*. A *futon* set consists of this undermattress, called a *shikibuton*, a lighter, fluffier coverlet known as a *kakebuton* (a duvet, essentially), and a pillow, or *makura*, traditionally filled with red beans or buckwheat chaff. Because Japanese homes are historically small, dual use of spaces became common, and many Japanese still follow the practice of folding up the *futon* set and storing it in a cupboard during the day.

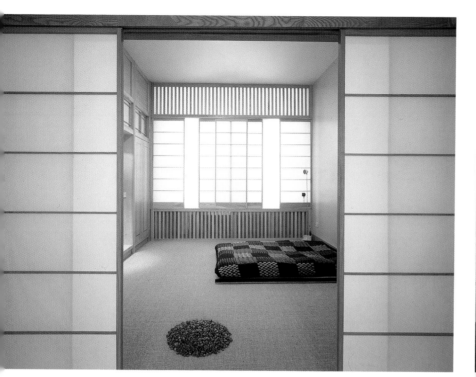

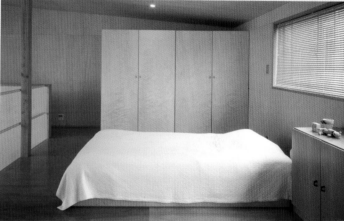

Opposite A mezzanine bedroom perched over the main living area of a house in Yokohama, under the exposed rafters. The bedroom's ceiling is of stretched lycra fabric.

Left Framed paper *shoji* screens and *tatami* flooring give an illusion of space and simplicity in this conversion. A neat circular mound of black pebbles breaks the rectilinear geometry.

Below In a contemporary and economical take on Japanese simplicity, this house is finished throughout in plywood, including the minimal bedroom, also occupying a mezzanine.

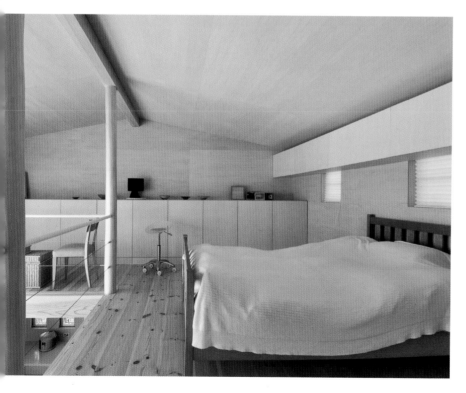

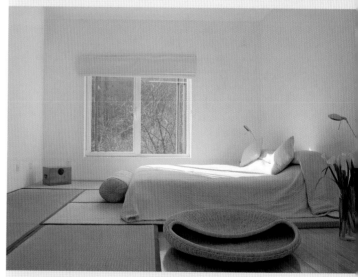

Left A mezzanine bedroom, supported by wooden pillars hewn from pine trunks, in absolute simplicity, using unpainted wood throughout.

Above A simple, almost austere bedroom, with *futon* and *tatami* mats in a plain white decor, in a development north of Beijing, near the Great Wall.

ASIAN BEDROOMS AND BATHROOMS

REPOSE **IN LUXURY**

In complete contrast to the minimalist styles of traditional Japanese sleeping and of contemporary white-and-natural bedroom design, these Asian bedrooms luxuriate in texture, softness, color and a full visual surround. The beds in all these examples are Western but the treatment is in the tradition of aristocratic luxury. One common theme is a large amount of upholstery: thick and soft mattresses, spreads and coverlets, and an abundance of cushions. A variety of fabrics is important, with fine silks playing a major role, supported by brocades, quilted cottons and even in one case fake fur. Color is the third ingredient in conveying a sense of pampered luxury; not a single, restrained color theme, but an exuberant and confident combination. There are many ways of approaching color, from complementaries in pastel, as in the soft blue and pale yellow bedroom at lower right, to the vibrant juxtaposition of red, emerald and gold in the Zhong Ya Ling apartment below. Red, a quintessentially Chinese hue of celebration and happiness, makes a strong and rich statement in two of the rooms here, while the deep blue bedspread above right adds an unmistakable feeling of luxury. Shot silks, particularly when used for pillows, are particularly eye-catching, as the cross-weave creates an iridescent effect.

Below The master bedroom of a Pudong apartment, with a moongate door, gold-lacquer screen, red silk lamps and silk fabrics, all designed by the owner, Zhong Ya Ling.
Right Rich colors that include Chinese red, and a variety of lacquered Chinese wooden panels distract attention from the extremely small dimensions of this bedroom.

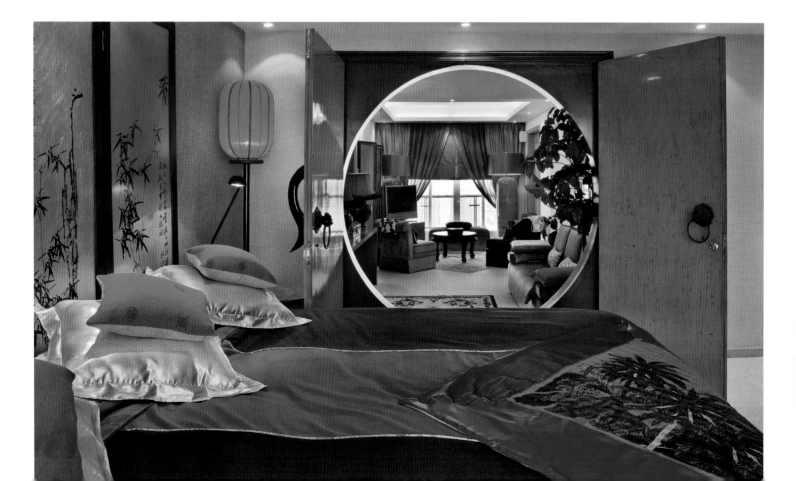

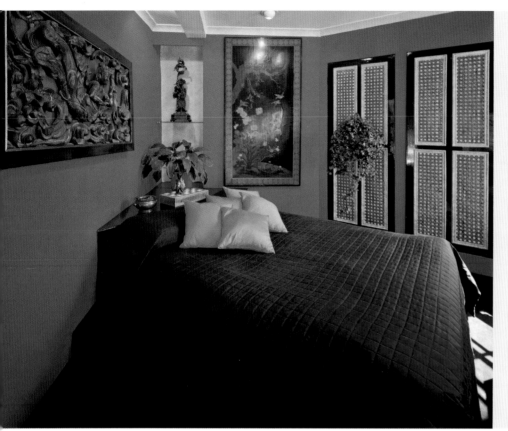

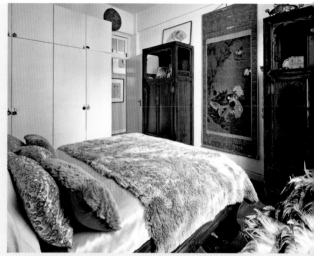

Above A yellow silk bed cover, brocade pillows, fake fur and feathers, in combination with two Shaanxi cabinets and a scroll painting, make a flamboyant textural statement in this Hong Kong apartment.

Below left The vibrant effect of patchwork quilt and silk brocade pillows is heightened in this Shanghai apartment by the doubling effect of the sliding mirror doors to the wardrobe.

Below Pale blue harmonizes with yellow and gold in this bedroom. The six-panel screen is modern, an interpretation of an old Song-dynasty screen.

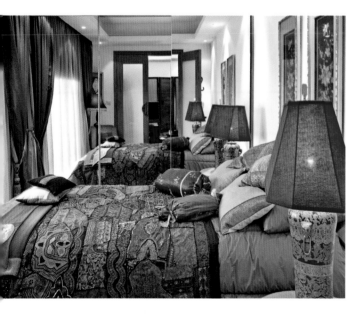

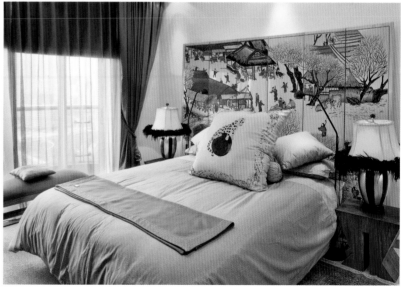

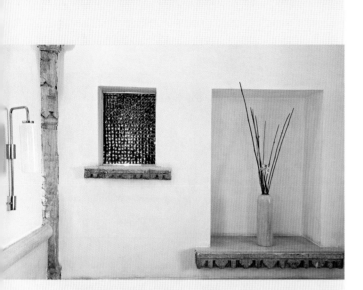

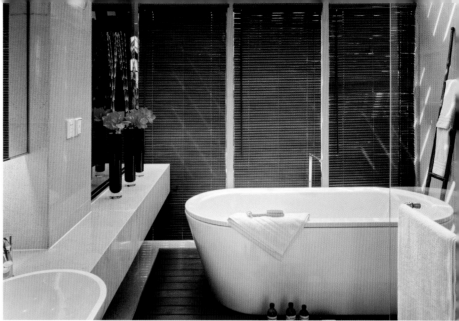

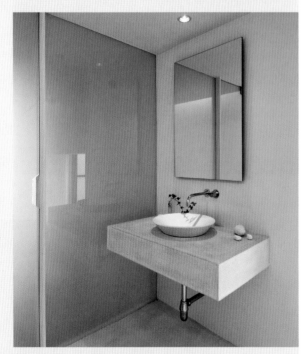

Top left A reworking of an old technique, the small alcove in this Indian home is decorated with *thekri* work—handblown glass balls coated inside with mercury, then broken and applied as a mosaic.

Top right A freestanding contemporary tub has pride of place in a bathroom in a large modern villa in Pudong, China.

Above Simplicity and calmness in this Tokyo washroom is achieved by diffuse lighting, sandblasted glass and a cream render.

Right Southeast Asian basketry and lacquerwork provide the decorative theme for this otherwise austerely white bathroom. A Karen minority basket with carrying straps is used as a laundry receptacle.

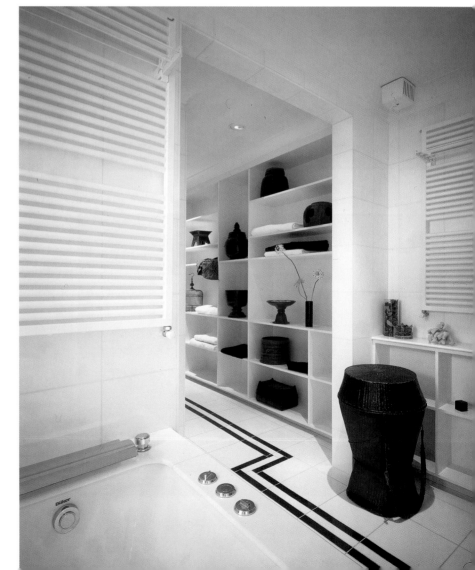

THE CONTEMPORARY **BATHROOM**

Modern bathrooms are, like bedrooms, characterized by clean lines, simplicity of decoration, a preference for white over fussy colors and an overall sense of coolness. In addition, the technology of bathroom fixtures and fittings has undergone major development in recent years, and contemporary Asian design is taking full advantage of this, from rain-head showers to washlets—the Japanese contribution to the automated toilet-cum-bidet experience. No longer is a bathroom a pure utility space to be entered and left as quickly as possible; with imagination, it becomes a space to enjoy and in which to luxuriate. While shower fixtures have evolved to give a range of effects, from rain to adjustable water massage, bathtubs are enjoying the attention of designers, with freestanding tubs having a contemporary makeover. Soaking in a tub, which is culturally essential for the Japanese, as we will see in a few pages, makes the decor of the bathroom even more important, as you will spend longer looking at it; Japanese architect Kengo Kuma, for the villa below, gave it pride of place with a spectacular sea view, and an unrestricted 180-degree view from the sunken bath.

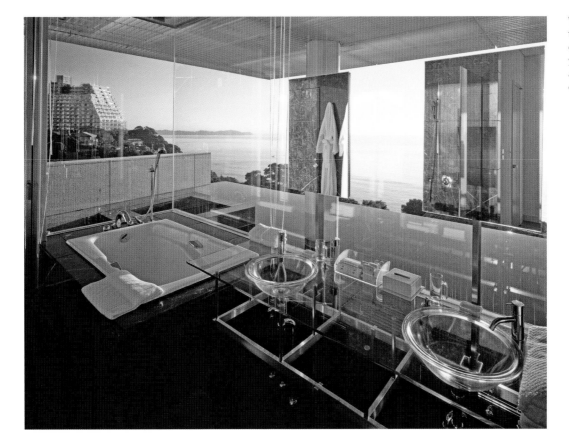

Water—the sea and the overflow pool on the balcony—and glass intermingle in this opulent yet contemporary bathroom in a villa overlooking Atami, Japan, designed by Kengo Kuma.

RETRO ASIAN **BATHROOMS**

Bathtubs are back. What used to be, by default, the ordinary stand-alone Western bath has been rediscovered for its luxury potential, helped of course by modern plumbing fixtures that allow unobtrusive or concealed flow and drainage. One of the motivations for this has been the incredible growth in popularity of spas, with the stress on soaking and the benefits of both oils and essences, and indeed, the spectacular bathroom at right, with its unashamed luxury and view, is in the Vanyavilas spa in Rajasthan, India. These are Western bathtubs (Japanese tubs, as we see on the following pages, are designed for sitting rather than reclining), but have been widely adopted in Asia, particularly in India through the influence of the British in the nineteenth century. Modern materials, in particular acrylic, have loosened the old design constraints, and modern bathtubs are available in a variety of shapes that allow for extra comfort and deep soaking. At the same time, enameled steel construction, though more expensive, gives a higher quality finish. With the bathtub now elevated to a higher design position, siting it centrally as the focus of attention in a bathroom makes a strong design statement, as in both the spa bathroom right and Kelly Hoppen's layout at far right.

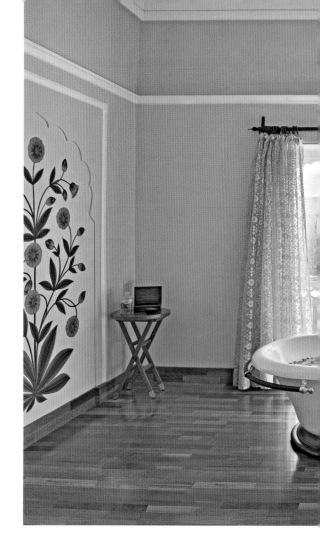

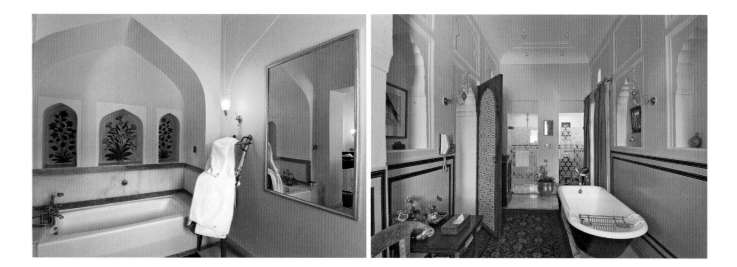

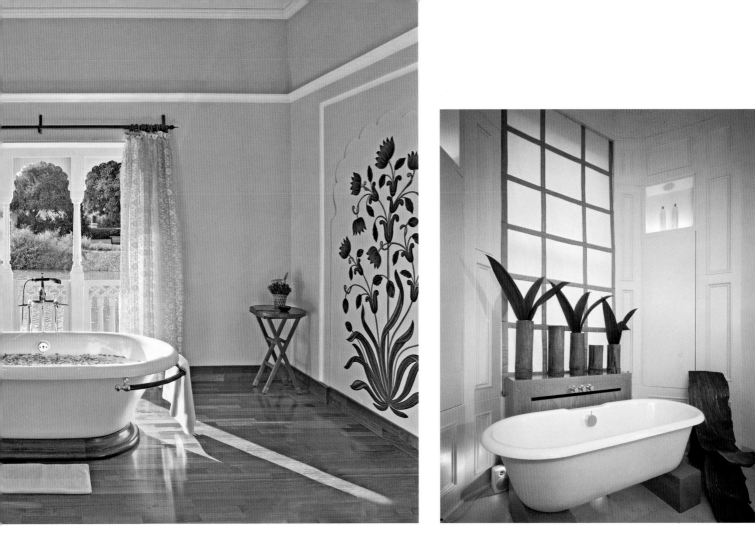

Far left The traditional northern Indian cusped arch in a repeating theme in one of the converted bathrooms in a private fort residence on the outskirts of Jaipur.
Left In the same fort-residence, designer Mirjana Oberoi has successfully combined the traditional architecture and furnishings, including bathtub and silver repoussé chair, with modern comforts that include a shower room.
Above Flanked by floral murals and looking out through a balcony onto a pond and gardens at Ranthambore, Rajasthan, this luxurious tub stands on a hardwood plinth and has curved wooden handrails.
Above right An Asian treatment for a classic bathtub includes mounting it on massive blocks of *wenge* wood, and adding a leafy decoration in the form of five Chinese wooden cylinder pots.
Right A nineteenth-century Thai bathroom near Petchburi preserves the then-common mixture of Asian influence (especially in the Chinese brass water basin supported on the low Thai stand) and Western (the contoured metal tub and the washstand with porcelain jug and basin).

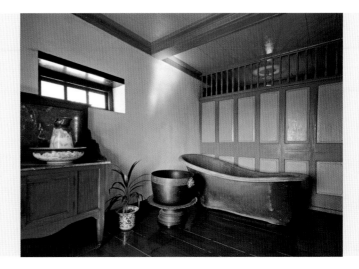

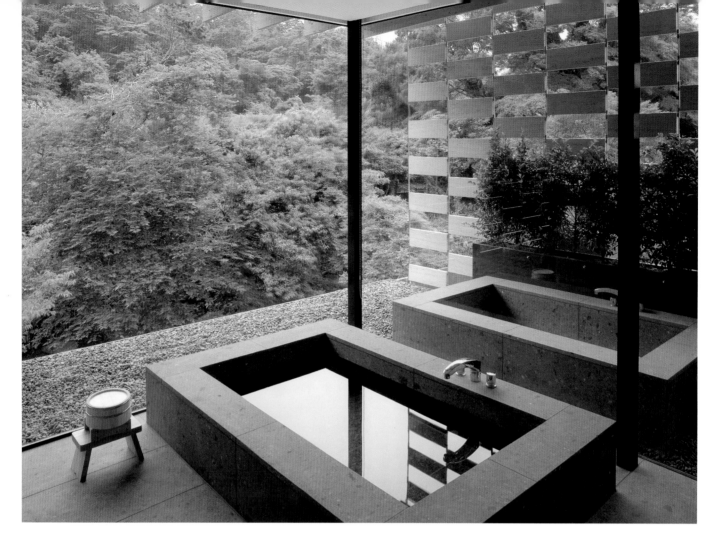

JAPANESE OFURO **STYLE**

The Japanese tub, or *ofuro*, occupies a distinctive place in bathing culture, strongly influenced by the country's high proportion of volcanic hot springs. Japan has one of the strongest hot spring bathing cultures in the world, and the practice and customs have spilled over, as it were, into bathing at home. An *ofuro*, or simply *furo*, is the traditional style of Japanese bathtub, essentially a straight-sided box, deep and short in contrast to the Western shallow and full-length design. The most common material is wood, preferably cypress, but stone is also occasionally used, borrowing from *onsen* practice (as in Kengo Kuma's design for a villa, above, with a choice of indoor or outdoor bathing). This bathing ritual focuses on soaking and warming rather than on cleaning, and as different members of the household use the same filling of hot water, it is considered essential to soap and clean oneself first outside the tub before entering in order to keep the water clean. Wooden cover planks, visible in the two examples at right, are used to keep the water warm between uses. Modern *ofuro* usually have a self-regulating heating mechanism. Because of the normal dimensions, and the way in which *onsen* are used, the *ofuro* is used for sitting and squatting rather than lying down, Western-style. This, not accidentally, makes it easy to fit an *ofuro* into even very small spaces.

Left A contemporary reworking of the traditional Japanese bathroom by renowned architect Kengo Kuma in a house with a forest view in Kanagawa. Two stone tubs, one indoors, the other outdoors, offer a choice of bathing according to the weather.

Right Though contemporary, this bathroom is in unpainted and unstained pine throughout. Cover boards for the tub are stacked at right, and a reed *yoshizu* screen filters the sunlight.

Below A non-traditional arrangement to make use of the limited space in this small Tokyo townhouse has the tub adjacent to a *tatami* room, but separated by a glass wall.

Below right This pine tub in a house in Sakuragaoka, near Tokyo, is covered with a set of seven planks, while a large porthole-like window faces south.

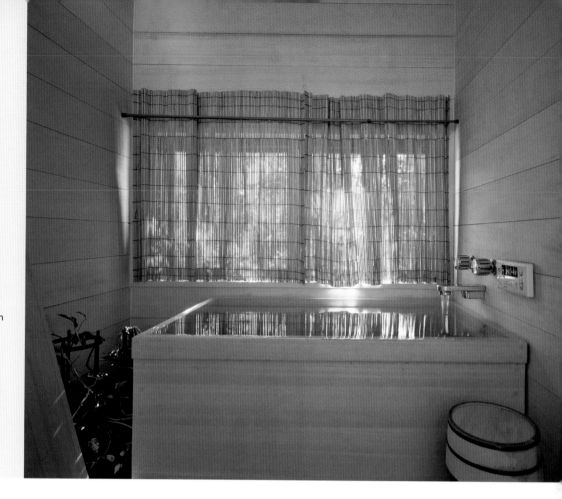

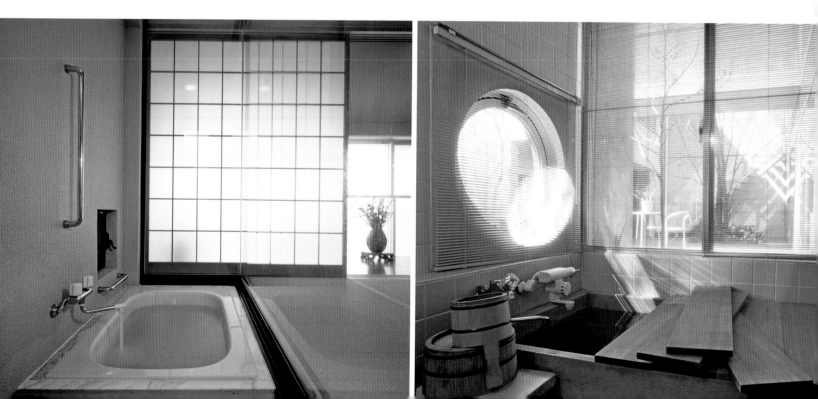

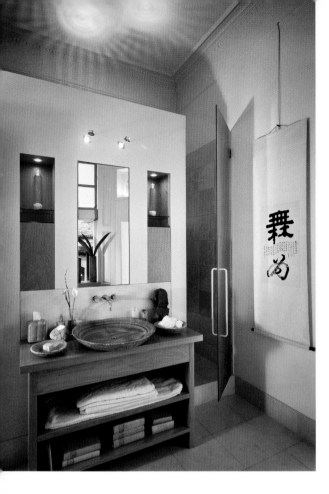

WASHBASIN **IDEAS**

Of all bathroom fixtures, the washbasin offers the most opportunities for varied design because its function is uncomplicated: it needs simply to be able to hold a few liters of water at waist height. As a result, not only has there been a mini explosion of contemporary design ideas in the commercial world of bathroom fixtures, but basins lend themselves to homemade invention. The basins here and on the following pages show ample evidence of imagination. Stone makes an excellent material although its weight demands structural support consideration. Rajiv Saini, taking advantage of the inexpensive and widely used stone works in Rajasthan and Gujarat, used marble very simply by fitting a diagonally sloping slab into a rectangular basin, while Singaporean architect Ko Shiou Hee had an elegantly curving basin milled out of a thick granite slab. Kelly Hoppen, left, adapted a shallow stone dish. Converting bowls designed for other uses to washbasins makes sense with ceramics also, as in the charming period washstand in a heritage Bangkok villa overleaf. Metal, too, can be pressed into use, and there are three quite different examples here that use copper or brass. The surroundings and stand also deserve thought and imagination, in particular the requisite mirror.

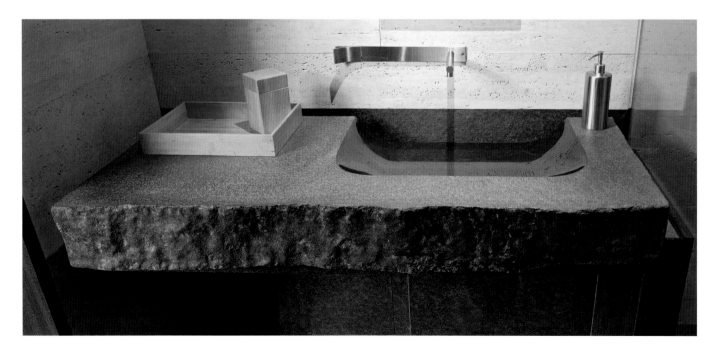

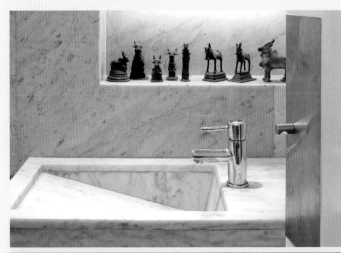

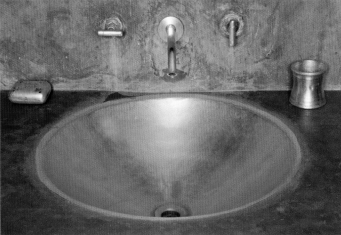

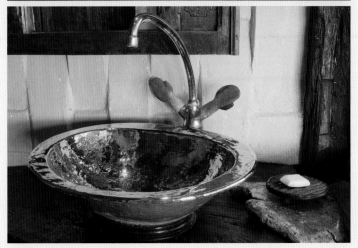

Opposite above For this Asian-themed bathroom designed by Kelly Hoppen for her own apartment, the washstand features an old shallow stone dish, drilled and fitted to the plumbing.

Opposite below A massive granite slab, left unfinished at the edge and milled out into a smooth depression for the basin, was designed for this Singapore bathroom by architect Ko Shiou Hee.

Above Confident color combinations in the fabrics, pots and flowers create the ambiance in a contemporary Shanghai apartment.

Above left A Mumbai bathroom, all in marble, includes a basin with a straight diagonal slope and a recessed niche housing a collection of figurines of Nandin, Lord Shiva's bull.

Center left A locally wrought Jaipur brass basin is sunk flush with the surface of this washstand which, like the wall, is finished in a dragged terracotta wash.

Left Another brass basin, hammered and polished in Bali, has the tap fitted with playful carved mitten handles.

ASIAN BEDROOMS AND BATHROOMS

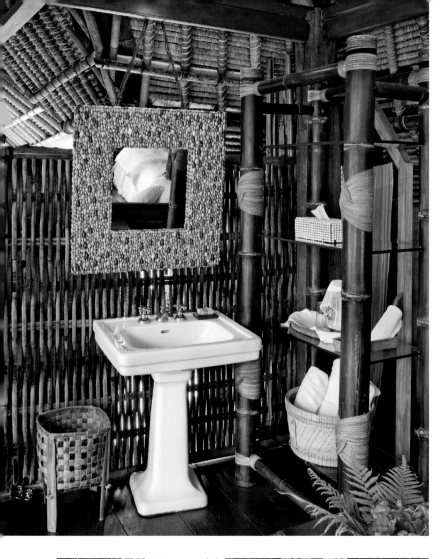

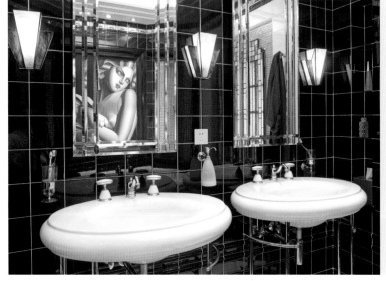

Above left A traditional English stand basin in a Balinese setting, with bamboo structural and decorative elements, and a mirror with a wide frame of shells.

Above The entrance to the small guest washroom in the living area of this Shanghai apartment is given presence by a long carpet and the celadon green pot with a small palm.

Left A meticulously restored Shanghai art deco bathroom in the French Concession district, with twin oval basins and a reflection of a Lolita Lempicka painting in the mirrors.

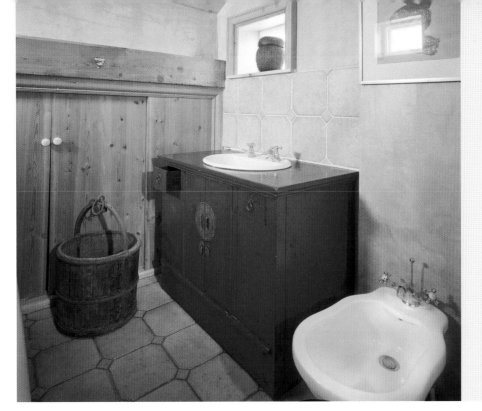

Left Collector Shirley Day has made striking use of a red nineteenth-century Chinese cabinet as a stand for her washbasin.

Below left In the same Balinese house as opposite, also with a shell-framed mirror, the basin in this bathroom is in beaten copper, supported imaginatively by a steel coil.

Below Matching Thai floral pattern ceramic bowls have been drilled and fitted to a marble-top wooden washstand dating from the early twentieth century, in the Ariyasom Villa in Bangkok.

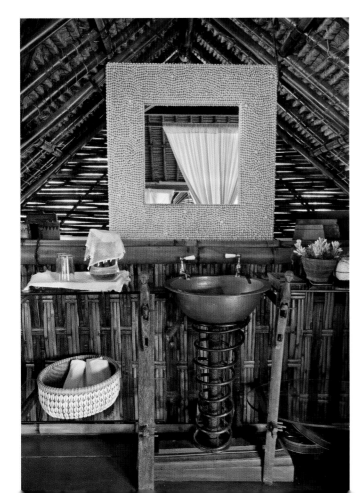

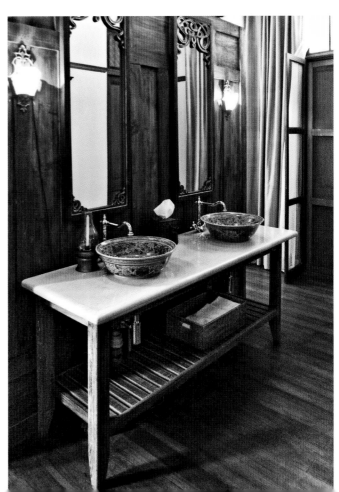

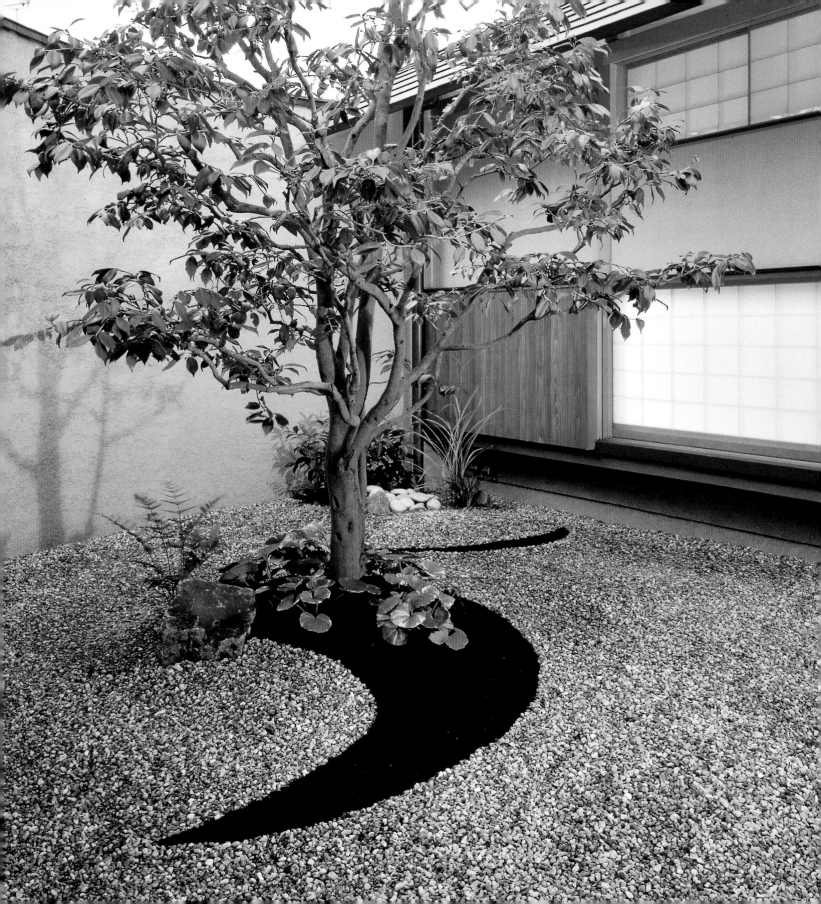

THE ART OF
THE GARDEN

Asian gardens at their finest and most formal are traditionally works of art. While acknowledging the influence on India of the Persian garden brought by the Mughals, the principal center of origin of garden thought and design in Asia is China, where the epitome of the classical garden was the Chinese Scholar's Garden. Gardens were considered to be such complex entities, demanding a spiritual and intellectual purpose and then needing a full knowledge of botany, architecture, hydraulics and *feng shui* (geomancy) in order to be able to achieve this purpose, that only a scholar with a full, rounded education was capable of creating a worthwhile one. The Chinese garden was taken up in Korea and Japan, and later in Southeast Asia. Contemplation was a primary function, both on nature and on Buddhist thought. The respect for nature came from Taoism, and separately in Japan from Shintoism. Buddhism, and in particular Zen Buddhism, encouraged symbolism—representing ideal landscapes through miniaturized ideas, with gravel representing seas, rocks islands, moss mounds a forest, and so on.

Contemporary garden design in Asia has, naturally, evolved from the old forms, but has to deal with different, smaller and more urban spaces, and with a freedom to use new materials and concepts. Despite this, even the most radical garden designer today in Asia can trace back ideas and principles to the early artistic and spiritual traditions. There tends to be a greater sense of integration of garden and home than in the West because of the tradition of exterior and interior spaces interpenetrating, one flowing into the other, with even an ambiguity over whether the meeting points are inside or outside or both. This means that, in a sense, Asian gardens work harder and make their presence felt more forcefully from inside the home. Almost all are in some way designed to present a structured view when seen from inside.

A curved wall on one side and a contemporary Japanese tearoom on the other enclose a gravel garden south of Osaka, designed by architect Chitoshi Kihara and garden designer Yasujirou Aoki. A single camellia (*Camellia wabisuke*) is planted in a crescent of black earth.

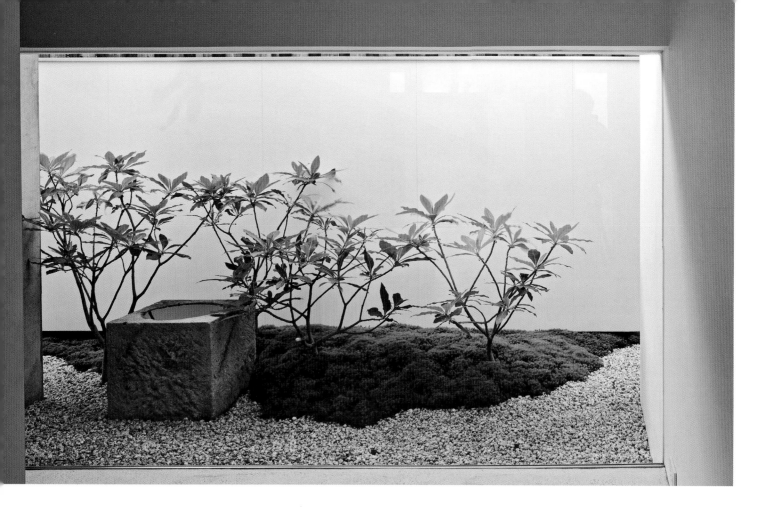

THE MODERN **JAPANESE GARDEN**

The Japanese garden is justly famous for its unique character, embracing rigor, simplicity and rich symbolism. Although its origins lie in Chinese garden design, the Japanese developed their own methods of expression. There are, in fact, many kinds of Japanese garden, but the ones here are all contemporary and share what is probably the most obvious characteristic—the careful and precise framing of view, presenting plants and stones in the same way that an artist composes a picture. The framing from the interior is achieved by carefully siting windows and sliding doors, and several here show the importance of creating a low opening, from floor level to below head height, so that the skyline is excluded from the view. As for the garden compositions within, they all, though newly designed, explore the long garden tradition in Japan, with the essential influences first of Shinto, with its emphasis on sacred nature, and also of Zen Buddhism, with its contemplative spirituality. Contemporary Japanese garden design has to work in smaller spaces, and particularly in urban environments, so that a common theme is presenting oases of natural calm, which often symbolize in miniature the distant forests, mountains and rivers.

Left A small viewing garden behind glass in a house in Kansai, Japan. The composition is precise and ordered, featuring a square *mizubachi*, moss, gravel and Oriental paperbush.

Right More precise framing, of a small, frosted glass-walled balcony outside a bathroom, based on divisions of a square, with a single pot of grasses.

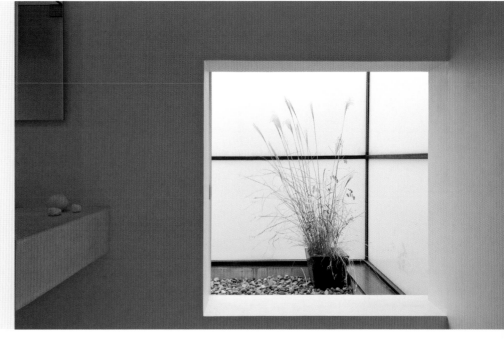

Below A carefully framed garden view for a painter's house and studio in Kyoto, exploits the slope of the ground outside and is composed as a vertical scene, using moss, stone and maple.

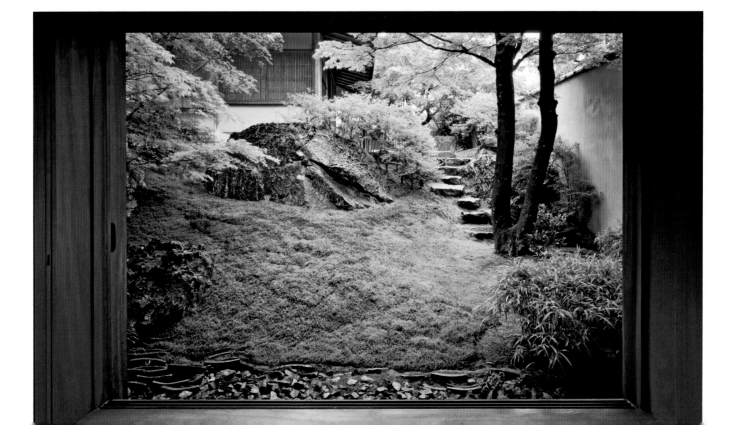

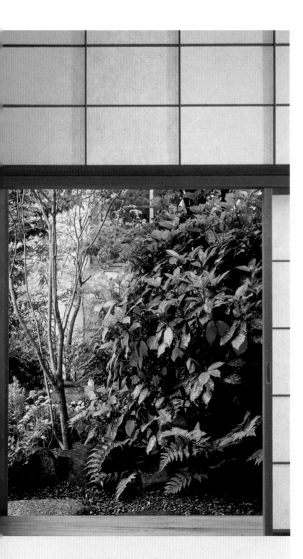

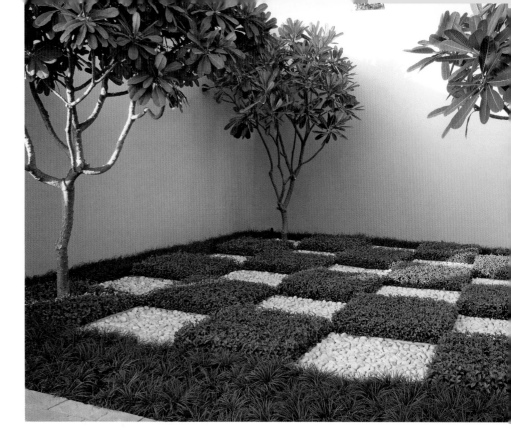

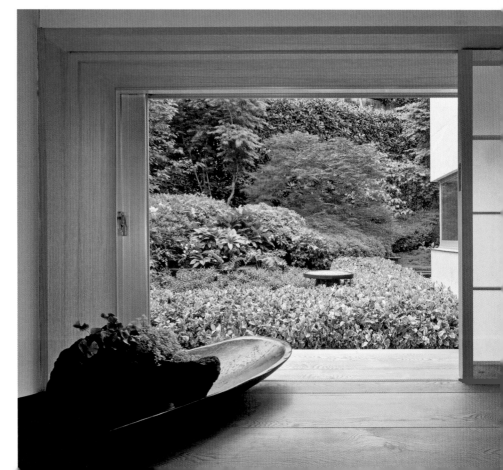

Above The plantings in this Japanese property were designed to deliberately create a "wall" effect framed by the *shoji* screens of a *tatami* room when slid open.

Above right A contemplative and secluded checker-board garden in India, created by Thai designer Pui Phornpraha. White pebbles alternate with wedelia, shaded by frangipanis.

Right A miniature moss arrangement in a shallow ceramic dish adds perspective and leads the eye through from the interior of a *tatami* room toward the narrow but fully planted perimeter garden that encircles this Kansai house.

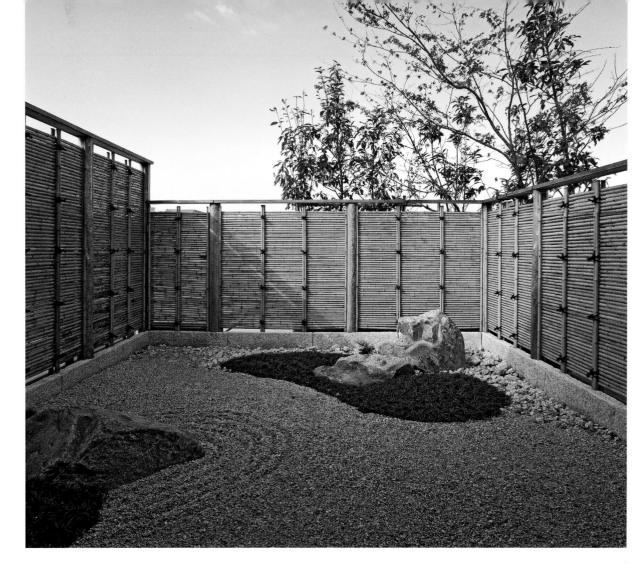

Above A rooftop Zen garden in the heart of Tokyo, with islands of stone and moss set in a swirling sea of gravel, is isolated from the surrounding district of Roppongi by a wall of hand-tied bamboo. **Right** A tiny exterior space adjacent to the entrance corridor of a house near Osaka is turned into a miniature landscape for viewing by the careful siting of the window, kept floor level to force the gaze downward.

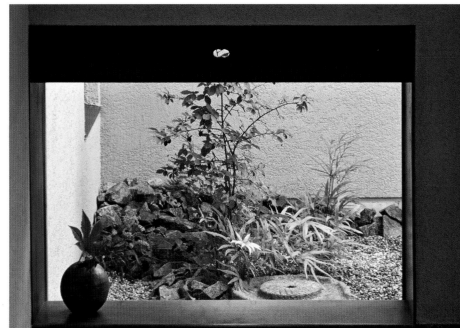

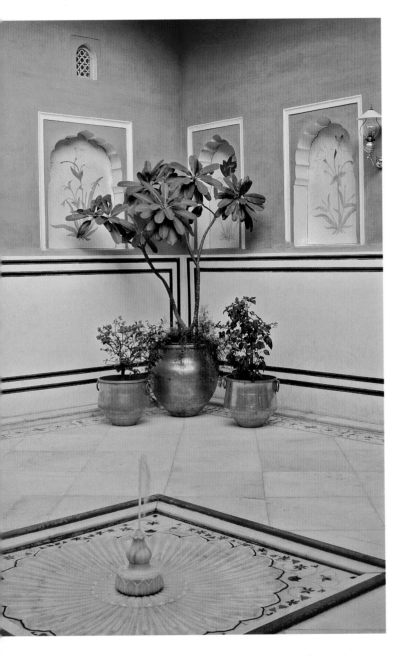

In a courtyard within a restored old Rajasthani hilltop fort, locally made brass containers house a frangipani and other plants, echoing the enclosed niche murals on the walls

MINIATURE GARDENS

The majority of urban homes have no space for a garden, and this trend is increasing as more urban living is concentrated in high-rise apartments, and yet the strong need in Asia for the garden's connection with nature still has to be met. There is already a strong tradition of miniaturizing gardens, particularly from Japan, in courtyards and other semi-open spaces within a home, and this can easily be taken further to the truly miniature world of containers. If you are accustomed to seeing islands, mountains and seas symbolized with stones, moss and gravel, it is a small step to seeing an entire garden contained within a vase or pot.

The containers in these examples are more than just receptacles for the soil that a single plant needs; they represent miniature natural worlds. The very simplest of these here is the tiny moss ball known in Japan as *kokedama*, sometimes called "the poor man's bonsai." With a packed soil core, the small size insures that plantings in it also stay small, and the ball is itself symbolic of nature. Context is important for a successful container garden. The grouping of three Indian brass containers at left relates beautifully to the marble and red stone courtyard in a private fort near Jaipur, the central fountain adding the cooling sound of water, while the square stone container below right was designed to fit within its granite balcony setting.

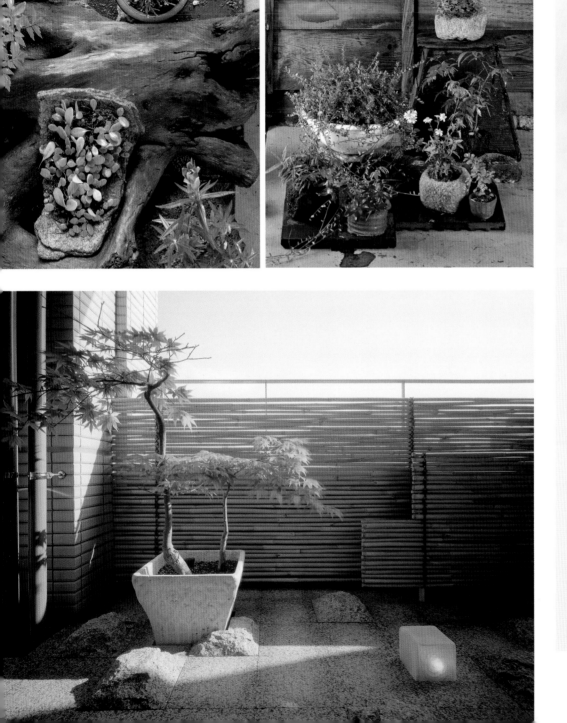

Above left and center Outside an old wooden townhouse in central Tokyo, one of the few remaining, the owner has followed tradition by placing selected potted plants in loose but carefully considered arrangements, making use of driftwood as a base and linking theme. **Above** *Kokedama*, or moss-ball bonsai, is a simple and decorative way of arranging small, single indoor plantings, here a wire-bent pine.

Left A tiny balcony in an apartment block in Tokyo by Takeshi Nagasaki features a surface of white granite arranged in a checkerboard pattern, with the rough-hewn blocks alluding to passing clouds.

THE ART OF THE GARDEN

Right A courtyard *karesansui* (dry-stone) garden in a contemporary Kyoto house, with a single maple. The doorway frames it precisely, excluding any distracting sky.
Opposite above An ancient gnarled ficus is the centerpiece of this courtyard in northern Thailand, set between Lanna-style buildings and a connecting wall.
Opposite below A minimalist sunken garden with a single flowering dogwood (*Cornus florida*) and decking, flanked by glass interior walls, by renowned architects Kazuyo Sejima and Ryue Nishizawa.

Below A small courtyard behind an old house close to the Forbidden City, Beijing, with a traditional arrangement of stones, bamboo, a circular stone table topped with glass and porcelain blue-and-white seats.
Below right The slim trunks of a Kousa dogwood (*Cornus kousa*) are contained in the center of this tiny upper-floor balcony in Tokyo, surrounded by a bench.

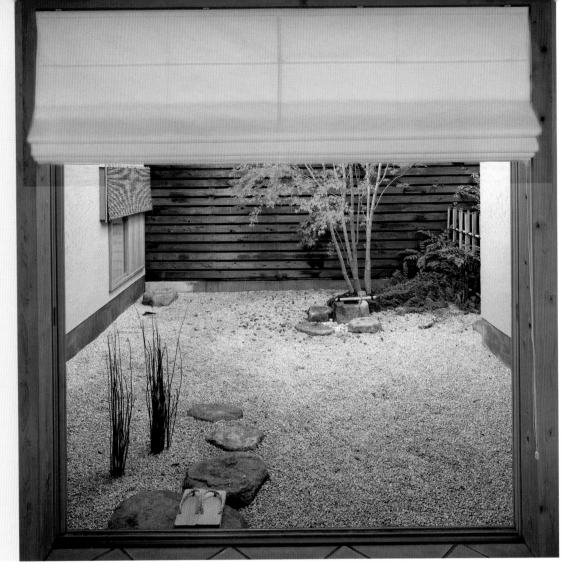

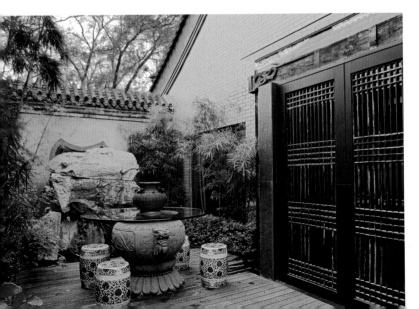

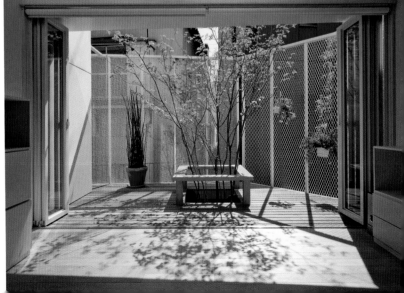

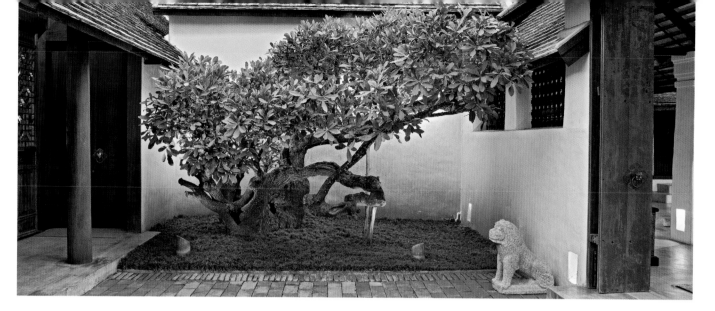

COURTYARD **GARDENS**

Courtyard living has a long history in Asia, from both the Chinese side and the Indian, and their combined influence has spread. The Chinese design of courtyard home dates back to the Han dynasty, and as one authority puts it, is "a paradigm whose inspired objectivity and richness of ideas has nurtured a form of intimate living." It is a perfect solution to maintaining privacy by closing off the outside world while opening up a secluded window to the sky. And when the courtyard is used to create a garden, it opens the home to nature also. Large size, as these examples show, is not a prerequisite, as the rich vocabulary of Asian garden design is well equipped to deal with small spaces. These spaces are organized for walking into as well as viewing, with the structured framed view that is so characteristic of Chinese-inspired and Japanese-developed garden design. Plants, rocks and settings are chosen thoughtfully and with a minimalist sensibility—no more than is necessary. In the case of the sunken courtyard in Tokyo by the internationally celebrated team of Kazuyo Sejima and Ryue Nishizawa, a single dogwood tree, carefully pruned, is sufficient to hold the interest.

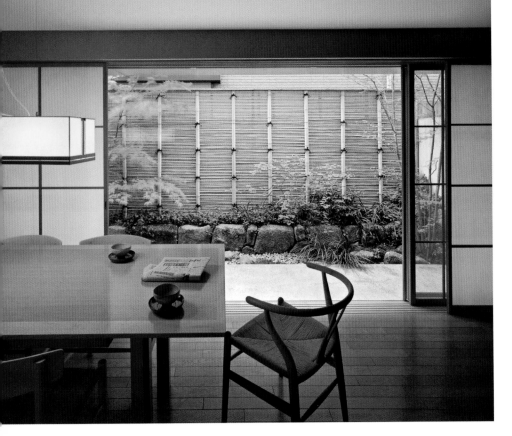

Above left The open space in this Tokyo house is long and narrow and runs along one side. Not large enough for a garden to walk in, it has been turned into a garden for viewing with a single sheet of non-reflecting glass looking out onto a bamboo screen backdrop and plantings of maple, fogwood, oak and hazel, with a stone-faced bed of shade-loving plants.
Above A small square courtyard connects two wings of this Kyoto house. By cutting a low opening in the wall at left, the plantings, by Yasujirou Aoki, are allowed to extend into the narrow graveled space in front of the property's external wall.

Left To bring life to an otherwise plain space at the foot of steps leading up to the rooftop of a Tokyo townhouse, the owners have constructed a container of old bricks for this planting.

Right A garden courtyard in the Chinese tradition of Anhui Province, featuring full-height walls for privacy and a collection of potted plants, including ferns.
Below The non-traditional divisions of these *shoji* sliding doors, together with concrete and a light screen of hanging chains, contrast with the softness of the just-glimpsed plantings in the garden.

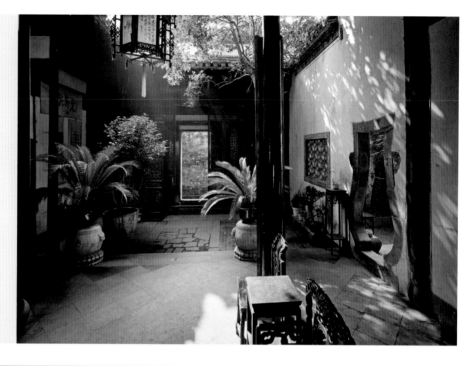

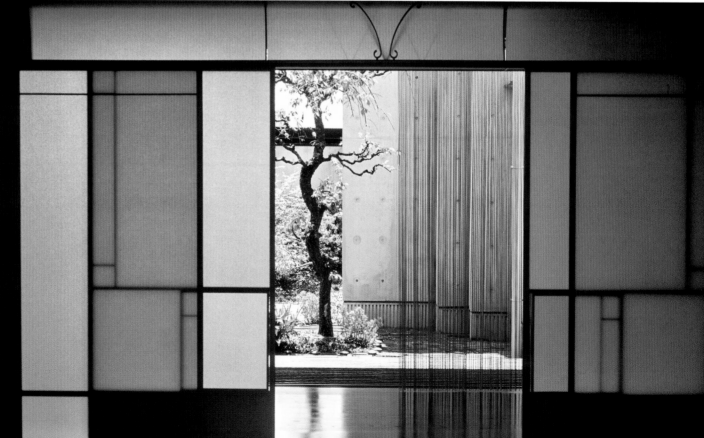

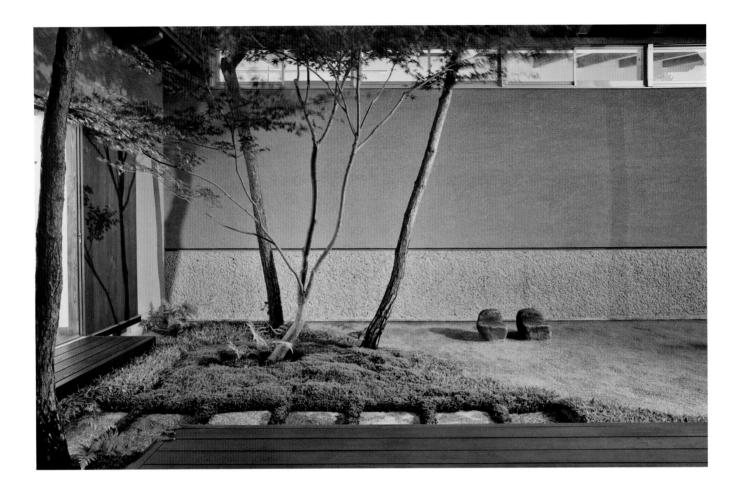

SCULPTING **WITH PLANTS**

With the strong sense of design and the willingness to use minimal planting that is so typical of many Asian cultures, the living component of a garden can be chosen and sited so that it plays a sculptural, structural role in holding the garden together. On the right of the page opposite are two excellent examples of how trees have been selected for the shape of their trunks and branches to complete a design, in both cases varieties of maple. What may not be immediately evident is that these young trees have then been pruned so that branches and leaves occur where the gardener deems them to have the greatest effect. The photograph above shows a remarkable example of this skill: the three branches diverge at different angles from the base to both alleviate the rigid rectangular geometry of the building and to tie the two halves together, while the lower arrangement of wispy leaves floats at yet another angle across the space. Ground cover, too, can be made to interact with other features such as a water basin, lower left and right, while the choice of plants in the basement garden above right rises in tandem with the steps formed by reclaimed old wooden railway ties, culminating at the top in a single cherry blossom, the whole making a symbol of nature rising from shadow to light.

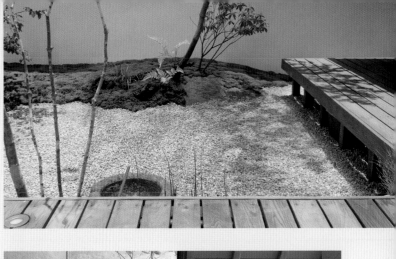

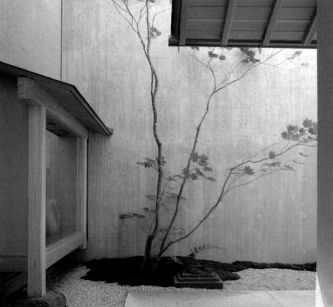

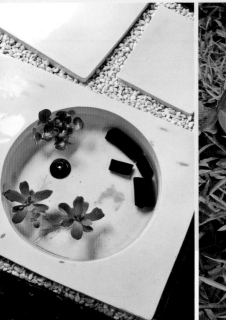

Opposite Occupying a courtyard space alongside the main living area, this simple Japanese garden is designed for viewing from the decking, access to which is through sliding windows. Beyond stepping stones, maples rise from a triangle of green ground cover.

Above left A small basement garden uses descending ledges made from old railway sleepers to draw light and plants down to this level from the upper garden.

Far left Inset into a cement floor stained with calligraphy ink at the entrance to a very rustic dwelling, a white ceramic abstract miniature garden with circular "pond" has been constructed by owner-artist Masahisa Koike.

Top A garden in Habikino, Kansai, by designer Toshiya Ogino, mixes gravel with an irregular long moss mound, framed on the opposite side with an L-shaped raised decking.

Above A carefully trained and pruned *A. Japonicum* maple tree, with a loose and flowing moss base, provides the necessary delicate, feathery counter-point to the geometrical severity of this external corner of concrete, gravel and wood.

Left A wild look is deliberately maintained in the front garden of a country house in Gunma Prefecture, Japan, by planting a dense ground cover of dwarf bamboo grass (*Sasa veitchii*).

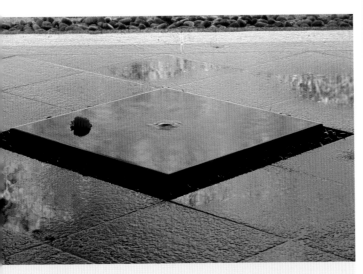

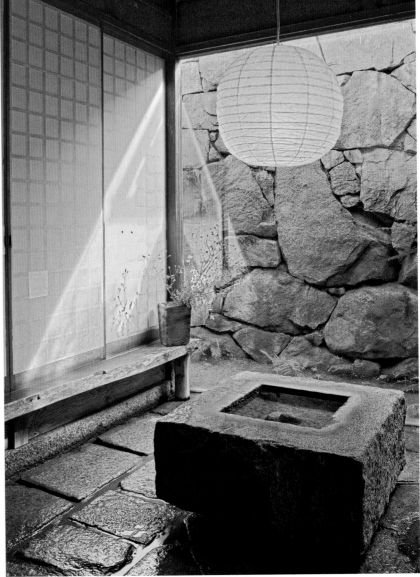

Above A low, gently overflowing fountain set in a diamond-shaped slab of polished black granite raised slightly above the surrounding stone pavement is an interesting feature at the front of a country house near Hiroshima. The trough is filled with black pebbles.

Right An Akari paper light by Isamu Noguchi, suspended over a massive square granite basin, combine to form a dramatic focal point in this tiny court garden.

Below A 12-ton boulder dominates the reflecting pool of a house in Bali. Approaching from the main entrance, the visitor first sees it past a wooden dish filled with marigolds.

Below center A restrained and subtle fountain built into a stone terrace that is part of a small weekend retreat in Hakone, Japan. The intention was to look natural and untended, and the circular basin is shallow to allow the stones to break the surface.

Below right A small corner arrangement in the gravel courtyard of a small Kyoto downtown temple includes a water basin carved as a circular depression within a sunken granite boulder.

WATER FEATURES

Water brings immediate life and a sense of coolness to any garden, and is a reminder of its central role in nature and life. In South Asia, fountains in Rajasthan and the north of India came from the Mughal tradition, itself one variant of the Persian garden, where water was a precious commodity and celebrated with pools and a flow of water that maximized the play of sunlight and created harmony through the interplay of sound, light and reflection. The Chinese and Japanese style stressed naturalness and gentle flow, even just a sonorous trickle. Stone in East Asia plays a key part in water features, and in the Japanese stone water basins known as *mizubachi* reaches its peak of quiet development. From the original design, tea masters developed a lower basin known as a *tsukubai*, or crouching basin, where guests arriving for a tea ceremony could wash their hands in a ritual cleansing, as in the example below right. Typically, these basins are fed by a bamboo spout known as a *kakei* (below). In contemporary gardens, the near-silent submersible electric pump has revolutionized design, making it possible to install water features anywhere. The water can be collected in a hidden reservoir and fed back up to the spout.

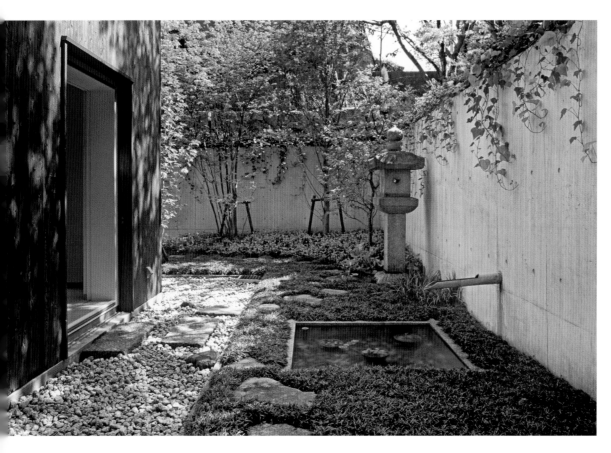

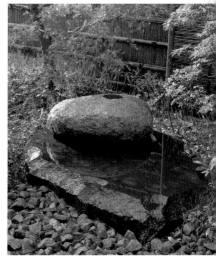

Left In an excavated sunken garden in Osaka, a bamboo spout, with its water supply embedded in the concrete wall, feeds a shallow square pond filled with pebbles, and with three stone bowls also containing pebbles.
Above A fountain by Zen priest and landscape gardener Shunmyo Masuno, consisting of a drilled weathered boulder, is sited asymmetrically on a slab of black granite.

THE ART OF THE GARDEN

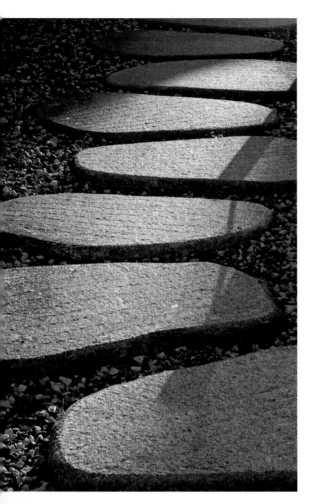

PATHWAYS IN
STONE AND WOOD

Paths are used with particular purpose in Asian gardens and play a significant part not just in directing the visitor around but in providing a special visual focus. Stroll gardens have their origin in China, where the primary purpose of the classical Chinese Scholar's Garden was contemplation, and one way to enhance this was to control the way in which you would experience the varied sights. The Japanese developed this idea more intensely in their versions of stroll gardens, called *kaiyu-shiki*. Pathways in a well-designed stroll garden do not simply wind around, but offer points that deliver fresh views, a concept in Japanese known as *tachidomaru*, meaning "stand, stop, look back." More than this, the pathway is also a strong visual feature of the garden, with stone the material of choice. In particular, the use of stepping stones rather than a continuous path brings the choice and shape of individual stones to the fore, as the examples here and on the following pages amply illustrate. More-over, this is especially suited to Asian gardens which make use of gravel pebbles to create a pristine "sea" between plantings, turning each stepping stone into a miniature island.

Above left Late afternoon sunlight catches the broad, flat-topped stones snaking across the grounds of a thirteenth-century temple in Kawagoe, Japan.
Left Square-cut stones are set staggered in their approach across a black pebble pond to the raised *tatami* room of a house in Hino, near Tokyo. The final large stone is for stepping up to the room.

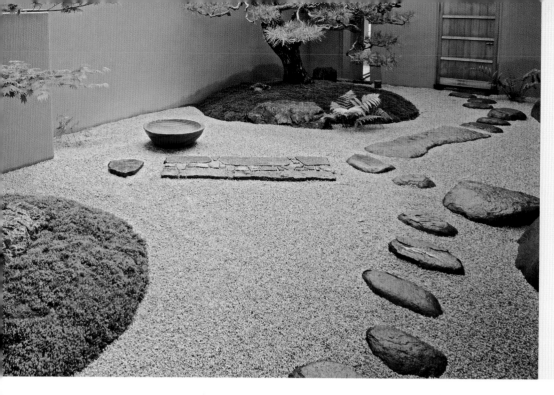

Left A branching arrangement of two different varieties of stone—one rounded, the other flat and nearly rectangular—links both entrances (one visible here), and in the middle ends enigmatically by a water-filled ceramic vessel, one of the owner-artist's creations.
Below At the beginning of a *roji*, or traditional meandering pathway leading to a teahouse, a single rope-tied stone known as a *sekimori-ishi* indicates that visitors should not enter.

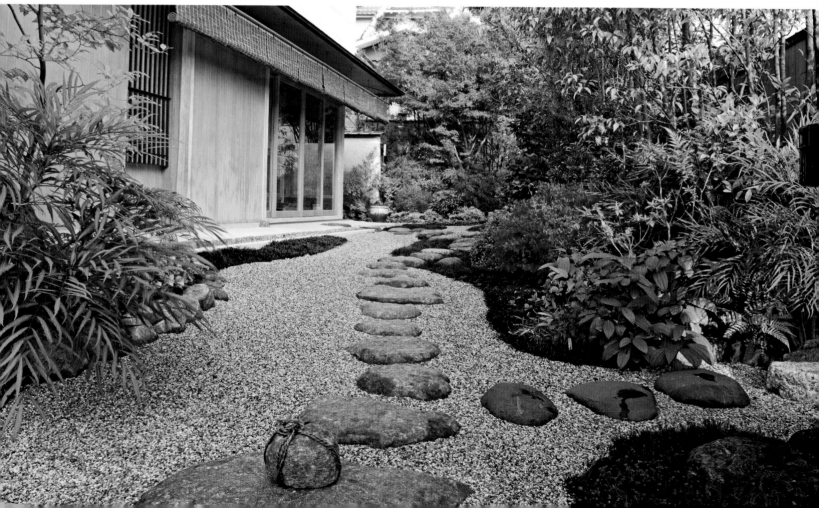

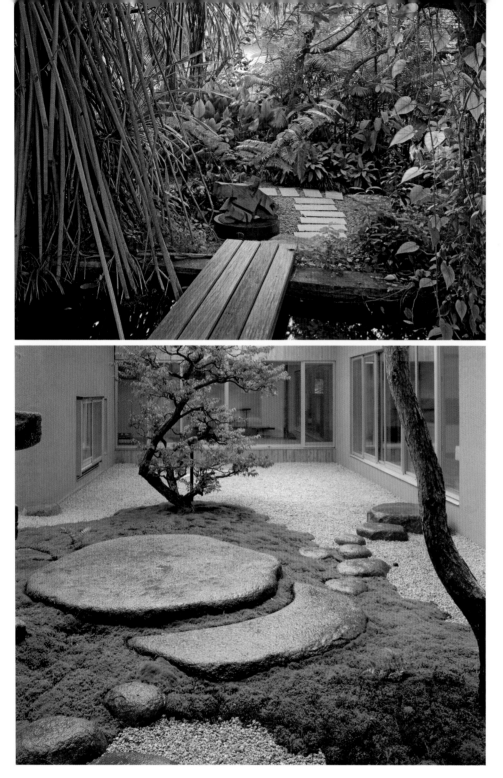

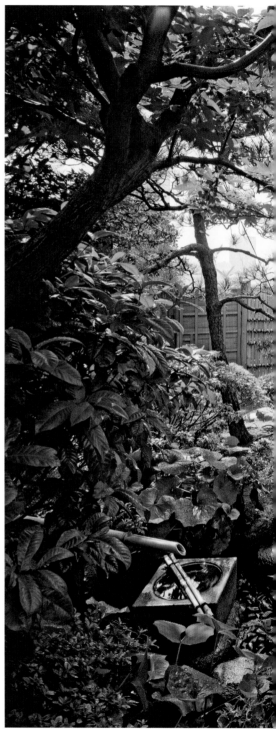

Top In a large Singapore property, architect Ko Shiou Hee has created a tropical stroll garden by mixing apparently casually placed stones and planking across a pond, all weaving through lush vegetation with no long views.

Above The stone pathway across the large courtyard between two wings of this house takes in a symbolic arrangement of two large stones representing the sun and crescent moon, embedded in moss.

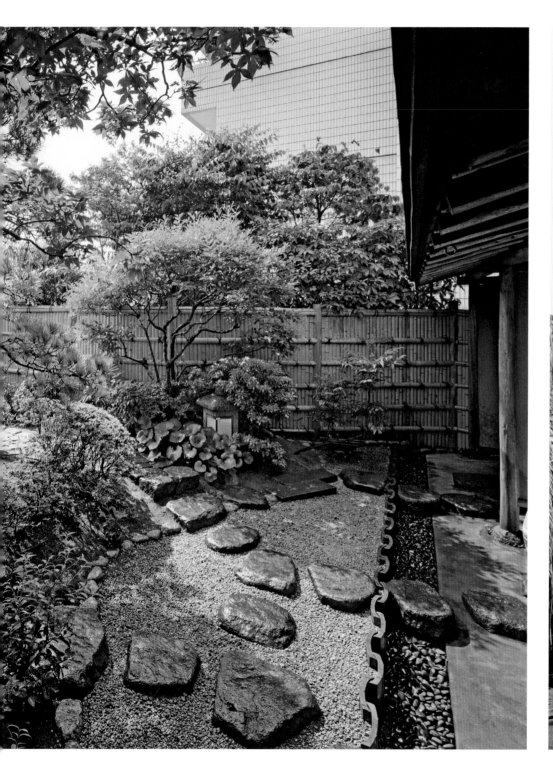

Left A traditional stone path design winds through a small garden leading to a teahouse on the right.

Below A deeply thatched gate in a property in Ubud, Bali, provides a glimpse of the pathway beyond, which branches left and right, indicated and separated by an arrangement of small river boulders.

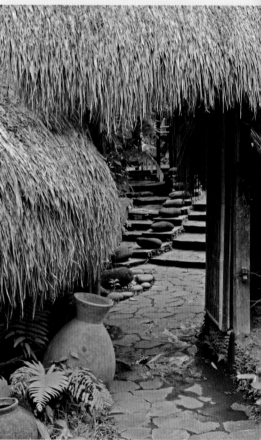

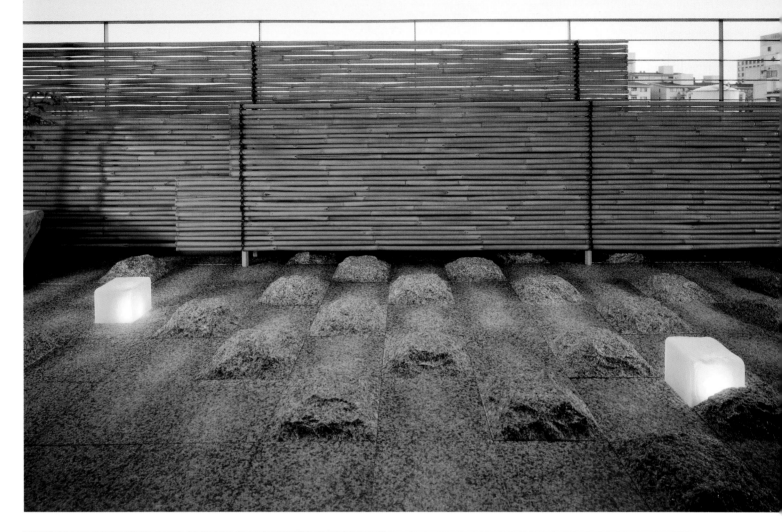

Above The checkerboard pattern of granite stones on this small "cloud-viewing" balcony in Tokyo features scattered rough-hewn raised blocks that represent the passage of clouds.

Left A carved stone block with a small circular depression makes a hidden water basin tucked under bushes at the margins of this garden.

Right Japanese artist and garden designer Takeshi Nagasaki modernized the concept of *ishigumi* (miniature gardens within a garden) by setting volcanic rocks in a thick concrete disk, that also functions as a low table.

Opposite above An old granite horse trough has been repurposed here, set in a shallow stream in a garden near Osaka.

Opposite below Black river pebbles are arranged on this concrete basin to leave a crescent. The pebble pond can be filled or left dry for varied effect, according to the mood of the owner.

A LOVE OF **STONE**

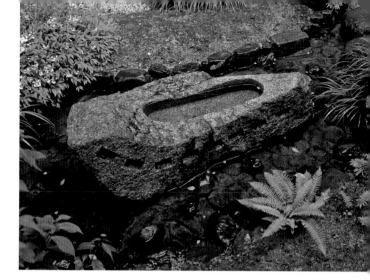

Individual stones play a deeper role in Asia than they do in the West, and are treated with more respect for their form and even their spirit. Instead of being considered as simply inanimate objects, more attention is paid to their origins, their type, and the ways in which they can suggest nature and symbolize larger natural forms. Seen as "living" objects that can play a full part in a garden, rocks can be thought of as having a kind of personality, in much the same way as Western gardeners would think of plants in terms of species. A well-chosen stone can complement the plantings and can even become a focal point of a garden of whatever size. Stones with "personality" need to be sited and placed with the same sensitivity that you would afford a tree or bush.

The love of stone for its own sake comes from the Chinese tradition, which spread to Korea and Japan, where it was subtly altered to fit into the particular culture of those countries. This is a deep tradition, and well worth exploring in any country. Sourcing stones is, of course, easier in Asia, where stone suppliers operate in much the same way as garden centers, but the practice is slowly spreading in Western countries.

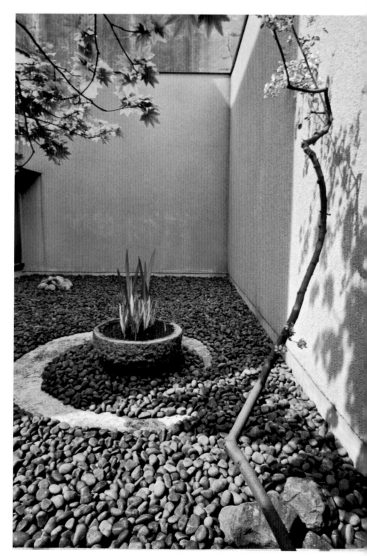

114

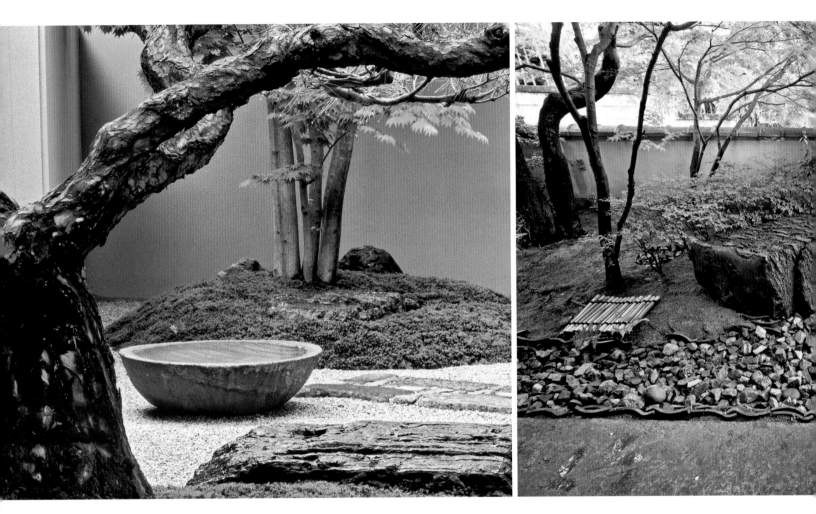

Above left Different kinds of rock are here arranged as stepping stones in a gravel garden to complement the stoneware ceramic basin, filled with water.

Above center This *saji-ishi* stone from Tottori Prefecture in Japan—highly appreciated and priced for its unique surface of deep runnels—serves as an inspirational piece outside the owner-artist's studio in Kyoto.

Left White pebbles form the ground of this small balcony in Tokyo. The cubic glass lights carry the impression of some of these pebbles, which were placed in the iron mold where the lights were handblown.

Right Moss covers an old stone horse trough set at the margin of a depression filled with large gravel and edged with Japanese roof tiles set edge on.

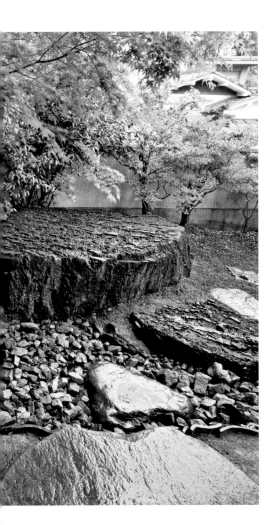

Above A small antique millstone has been used here decoratively. Note the common Japanese practice of siting elements on the edge between two surfaces.
Below A *kutsunugi-ishi*, or stone for removing shoes, traditionally set in front of the entrance to a teahouse or any traditional *tatami* room.

Above Granite pebbles, backed by galvanized iron, form the base of a glass-fronted display space in this house that is used to present individual works of art, like a small garden gallery.
Below Unusual rock forms have always been prized for their variety in Asian garden ornamentation.

Below Two species of bamboo confront each other in a narrow triangular space beside the entrance to a house occupying an irregular plot. The architect made a viewing space from this, with opposing wooden and concrete walls.
Right Another instance where the narrow footprint of bamboo makes it useful for planting in a very confined space, here an extremely small garden between the outer concrete street wall and the sliding screens of a *tatami* room.
Below right Rusted iron sheets provide a tonal and textural backdrop for a simple planting of bamboo, together with a *kokedama* bonsai.

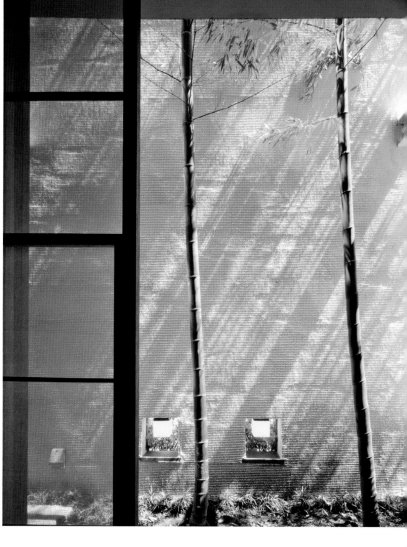

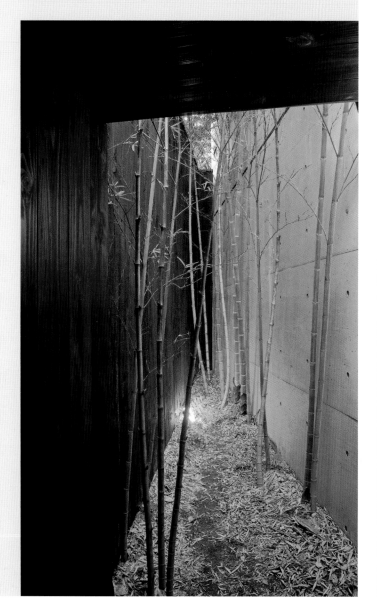

ASIAN BAMBOO

Bamboo, a kind of perennial grass, occupies a special place in garden thought and design, with its strongest links to Asia. Bamboo pervades Asian history and culture, and spiritually represents resilience and strength. It is the common name for the grass subfamily Bambuseae, which has 91 genera and a staggering 1,000 species, from low plants that really do look like grass ground cover to the massive Moso, averaging 7 inches (18 cm) in diameter and 75 feet (23 m) in height. Sculptural is, indeed, probably the most valuable and remarkable quality that bamboo offers the garden designer. Large bamboos have an almost architectural, structural feel, and can be used in a variety of ways, from a central presence around which the rest of the plantings are organized to backdrops, while the contrast between sturdy culms and feathery leaves is a constant delight. Bamboo is the fastest growing of all woody plants, which makes it feasible to get a mature assembly in a reasonable space of time. Its small "footprint" also makes it ideal for small garden spaces (see the planting in an otherwise unplantable narrow triangular space here), and its visually strong vertical lines encourage several design ideas. There are bamboo colors to suit all tastes, from green to variegated to black.

Above Bamboo planted indoors makes a contrast with a playful arrangement of long steel troughs containing white gravel and moss that have been mounted on a wall. **Below** Sturdy green *mosodake* bamboo (*Phyllostachys pubescens*) is made to grow vertically in an ordered fashion by a horizontal frame 6½ feet (2 meters) up in this sunken garden surrounding a Japanese teahouse.

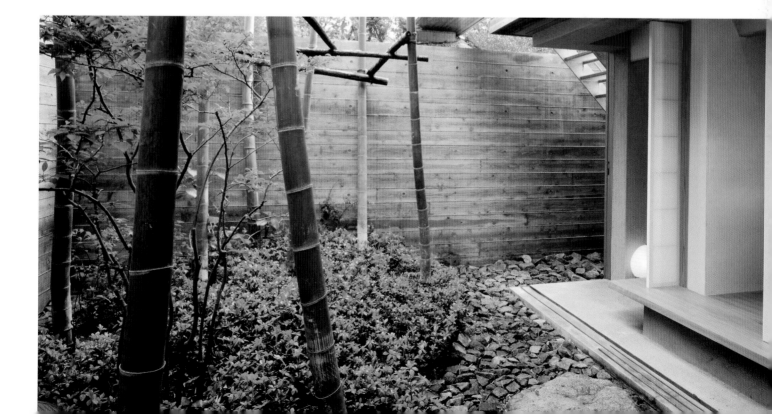

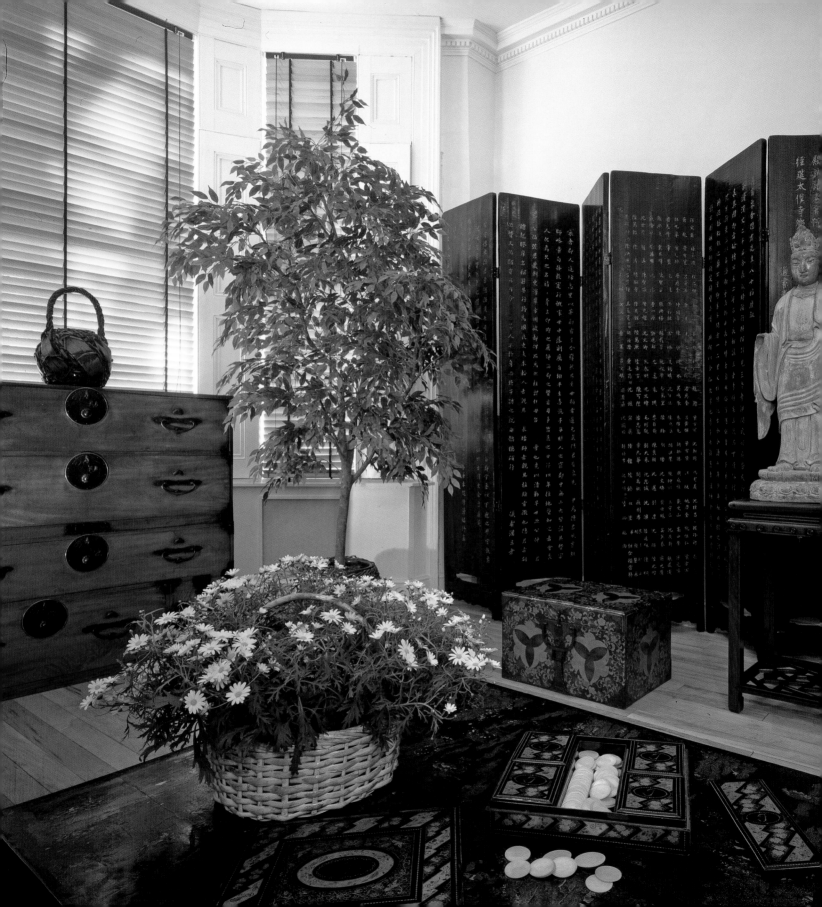

ASIAN ACCENTS AND FURNITURE

Asian furniture shows even more cultural variety than does the design and utilization of interior spaces, simply because individual pieces have more flexibility than entire rooms. Nevertheless, the two major influences make their presence felt, Chinese and Indian, with some Polynesian accents appearing in the eastern archipelago of Indonesia, and some Arabic accents making themselves felt through the history of Indian design. One lengthy, important change in lifestyle throughout Asia was the gradual rise of the center of gravity within the home, from floor level to table level. This is reflected in the increasing height of tables, and in the appearance of chairs, and one important influence on this was the spread of Buddhism and the idea of elevating images of the Buddha and of monks.

From Chinese furniture evolved Korean and Japanese, each adding its own individuality. Chinese Ming and Qing styles are the most popular and distinctive classically, Ming with its refined and minimal lines, exquisite cabinetry with no metal joinery, and often rare hard-woods, Qing more affordable and rather more decorative. Korean furniture tends to be lower than most, and one distinctive style makes exquisite use of yellow and white brass fittings. Japanese furniture includes, among others, the distinctive cupboards known as *tansu*. Vietnamese and Thai furniture also draw heavily on Chinese origins. Antique furniture is, of course, an excellent option if money is no object, but the most sought-after periods and styles, such as Ming, are increasingly rare and expensive, particularly in such woods as *huanghuali* and *zitan*. However, there are now many furniture manufacturers offering top-quality reproductions. Another option is to go for less well-known regions, such as Shanxi in China, or for rustic styles such as in bamboo.

A ten-panel hinged Chinese black lacquer screen bearing gilded calligraphy makes an immediate and striking change to this room, infusing it with a certain grandeur, and creating a strong backdrop for a Chinese statue of Guan Yin.

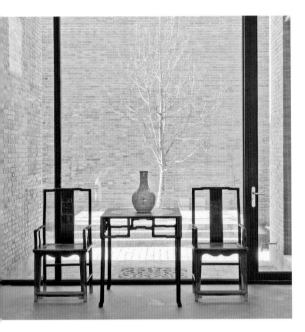

THE CHINESE CHAIR

It was during the Tang dynasty (618–907 CE) that small folding stools began to evolve into stately, high-backed chairs. By the Ming dynasty, chairs had been refined into sophisticated yet seemingly simple designs. The use of hardwoods, such as *huang-huali* and *zitan*, made it possible to keep the frame thin and well proportioned, and cabinetry had developed to such a point that joints were virtually invisible. The two most imposing styles, with many of the finest examples from the sixteenth and seventeenth centuries, are the officials' chairs known in modern terminology as "yoke-back" and "southern official's." The former, also called *guanmaoyi* ("offical's hat chair") had characteristic wings extending to the crestrail, which visually added to the status of the sitter, while the latter had softer and lower lines, the armrests and crestrail flowing into the posts without an angle. Lower and more fluid still is the equally famous "horseshoe-back" chair. All of these stately chairs are broad and spacious. Beyond these classics are numerous simple side chairs, rose chairs, folding chairs and a variety of stools.

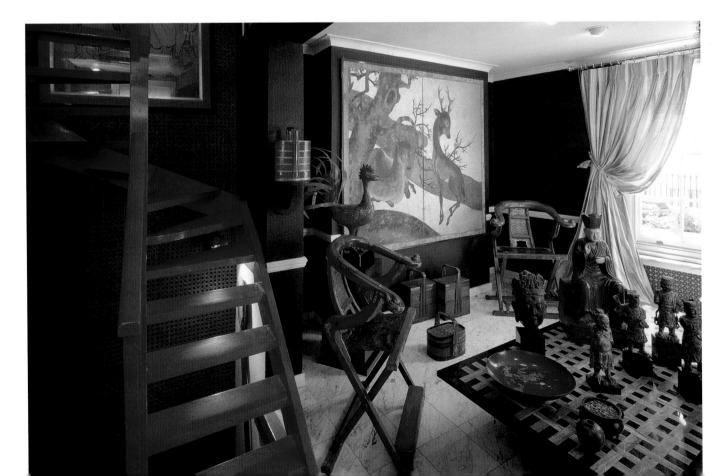

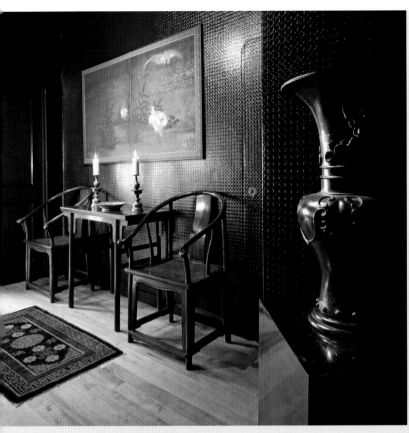

Above A pair of *qanyi* horseshoe-back rosewood chairs (the term "horseshoe" is a Western description) flank a side table in a traditional arrangement, against a black lattice-texture wallpaper.
Above right Another pair of eighteenth-century Chinese *qanyi* chairs are sited in a corner on either side of a black-lacquered incense stand in elmwood.
Right A Chinese bamboo reclining chair in rustic style. The footrest, here seen in a halfway position, slides out for use or retracts fully underneath.

Opposite above In an artist's house in the north of Beijing, two chairs flank an occasional table graced by a vase, and contribute to the framed view of a simple garden.
Left Two Qing folding chairs with curved backs make an eye-catching addition to this small room. Such chairs were used by the aristocracy on outings and when hunting.

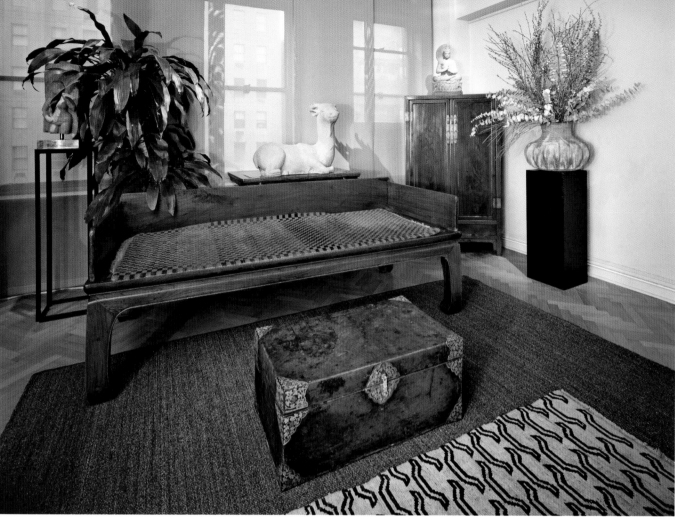

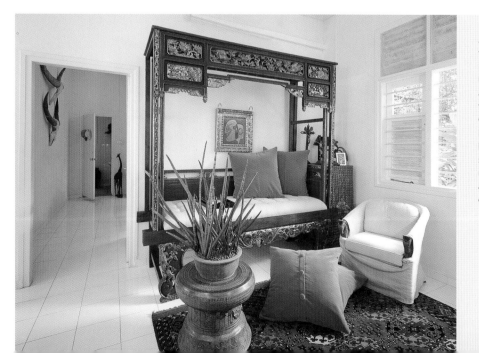

Above A Tibetan tiger rug, a small Tibetan painted trunk and a Chinese couch bed with a plain solid back and sides make an ordered arrangement.
Left A Qing-dynasty *jiazi chuang* (canopy bed) has a light structure but ornate finish, with floral forest-themed carved frame and upper panels, all gilded. Oatmeal-colored fitted upholstery and a pair of large orange cushions add contemporary comfort.
Right A *luohan chuang*, or couch bed, with understated elegance from the Ming dynasty and in the rare *huanghuali* wood, upholstered in rich blues and orange, is allowed to dominate this clean, glass-walled space.

DAYBEDS

Daybeds, of Chinese and Indian origin, have traditionally played a large role in Asian living than has the nearest Western equivalent, the chaise longue. The *charpoy* of the Indian subcontinent and the several styles of Chinese daybed were used for sleeping and for all kinds of daytime activities, such as working, reading, resting. In fact, the *ta* or plain Chinese daybed was the most popular item of furniture in a Chinese home. Its height made it convenient for sitting cross-legged on it, or with feet on the ground, and when fitted with an armrest was perfect for reading. In warm weather, it could be carried out into the garden. In contemporary use, it is normal to have some kind of soft furnishing, either a fitted cushion or a soft rug. Chinese canopy beds can also be converted to use as daybeds, as in the example below left—and once again fitted with a custom-made mattress and cushions.

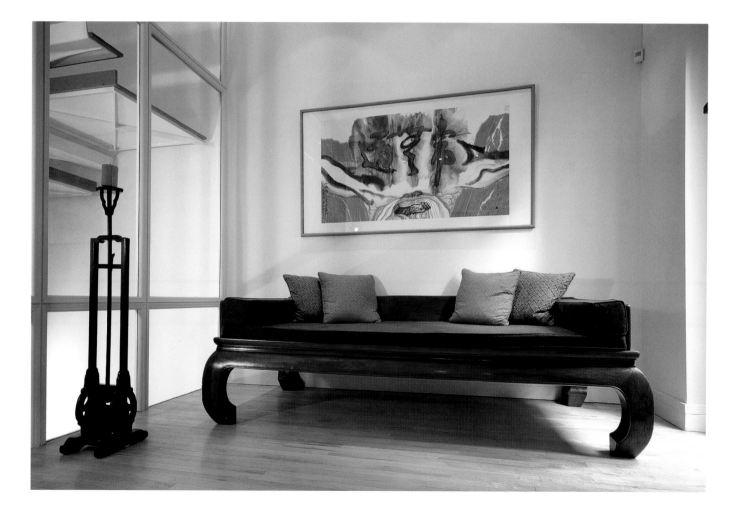

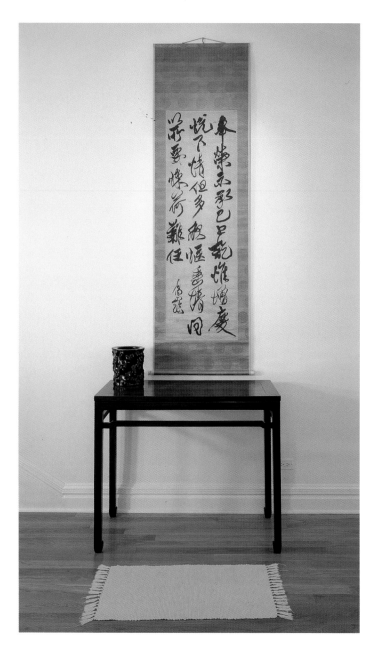

A seventeenth-century calligraphy scroll by the famous scholar-artist Fu Shan, who transformed Chinese calligraphy, hangs over an Eight Immortals Table, or *baxianzhuo*, in highly prized *zitan* wood. *Zitan* is a rare and very dense tropical wood of the rosewood family. Square tables in this simple design, the dimensions of a cube, are named after the Eight Taoist Immortal Beings (Xian).

SIDE TABLES

Display plays an important part in classic Asian interiors, with both religious and secular influences. Sculpted imagery in Buddhism and Hinduism needs stands of one kind or another, and at an elevated height, and as a result many Asian cultures have developed a range of furniture specifically for this purpose. As icons, sculptures tend to be placed against a wall, the most typical form of "altar" being a kind of side table. These "altars" vary in elaboration, and a full set in the Buddha room of a grand Thai house, or in a temple, would run to several tables that fit together at different heights. Side tables have secular functions also, such as in a classical Chinese scholar's study for displaying contemplative objects like stones and polished sections of wood. Side tables are necessarily long and narrow in proportion. In China, the two most common forms were recessed-leg construction or a one-piece carved-out leg construction. In the former, the tops of the legs are inset from the corners and typically splay outward toward the base. In the second style, single pieces of wood at each end are hollowed out. But other pieces of furniture can also be used for display, such as the two examples at right illustrate.

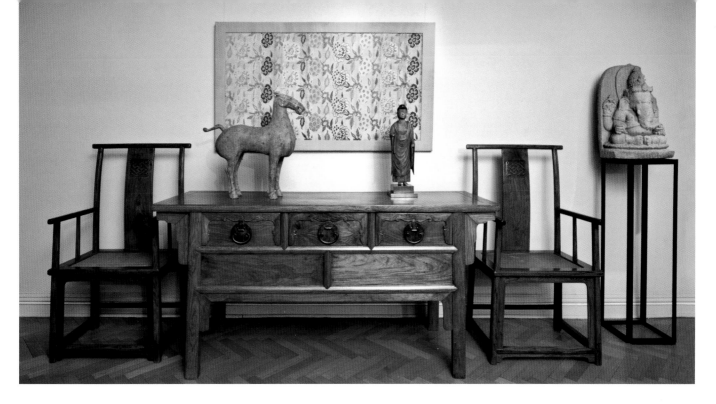

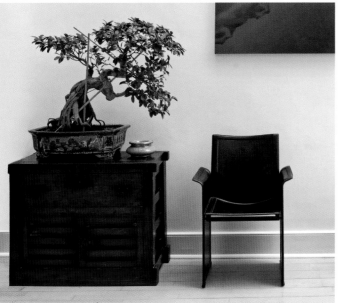

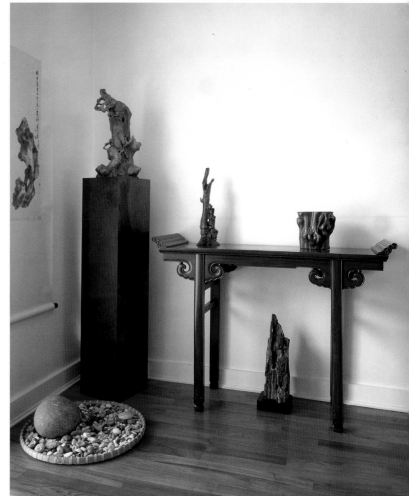

Top A classical arrangement of Chinese furniture in the Manhattan apartment of a notable collector features a side table with deep drawers in *yuna* wood, on which are a ceramic Ming horse and a statue of the Buddha, and two yoke-back chairs.

Above A Japanese *tansu* serves to hold a bonsai, the form of which continues into a painting by Beijing artist Shao Fan.

Right A collection of Chinese "scholar's rocks" and polished natural wood, together with a *gongzhuo*, or altar table, with everted flanges.

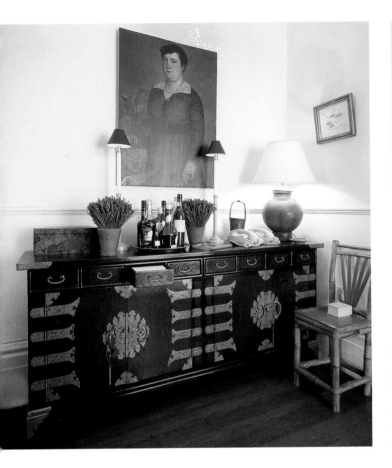

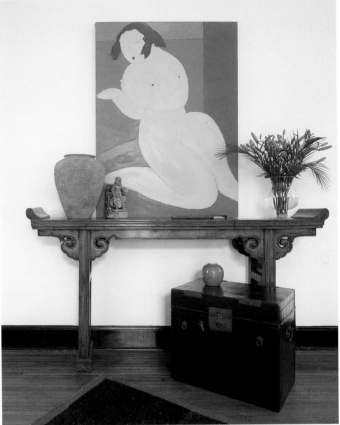

Above An elaborate Korean chest with multiple small drawers above the cupboards, with brass fittings.

Above right A nineteenth-century altar table from Shaanxi Province, its everted flanges and cloud scroll tops to the legs typical of the region and style. Above is a painting by contemporary artist Pang Yong Jie, and below a document box for transporting legal papers.

Right Two antique Japanese *tansu* chests provide decorative storage space as well as a display platform for a variety of objects.

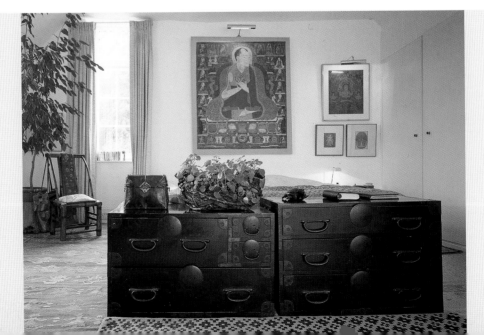

ASIA HOME

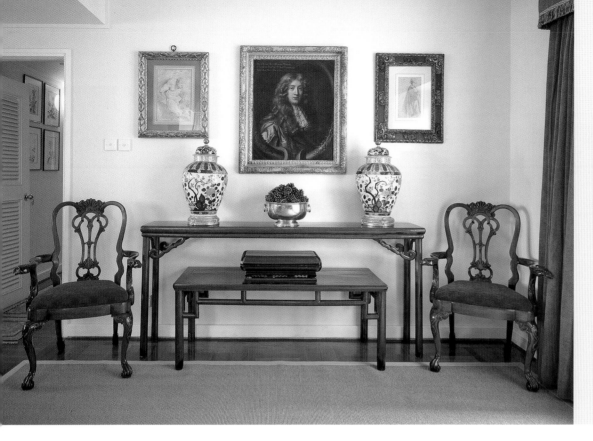

Left In this amalgam of classical and European and Chinese styles, two Chippendale chairs flank an eighteenth-century elmwood side table from Shaanxi Province, while a lower table with rectilinear stretchers and struts proves the harmonious adaptability of good furniture regardless of provenance.

Below left A richly painted Tibetan chest with a marked patina is both decorative in its own right and is a display stand for a Japanese woven basket and a Chinese stone Buddha head.

Below center and right Two red lacquer Chinese cabinets, one small enough for a bedside table to carry a reading lamp, the other a little more substantial to fit below a living room window.

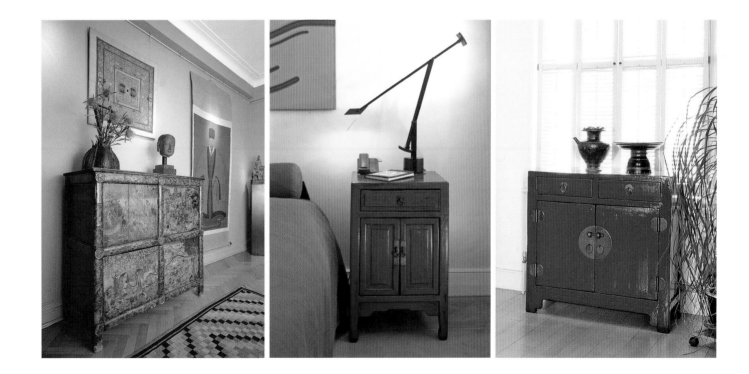

ASIAN ACCENTS AND FURNITURE

THE LOW TABLE
TRADITION

Early tables in Asia were low in proportion to the usual custom of sitting
on the floor, whether cross-legged, legs folded to one side or kneeling. Where
the custom persisted, as in many Southeast Asian countries as well as Korea and
Japan, so did this style of table, while in the north of China it developed a differ-
ent use. Here, to cope with winters, the traditional solution was a sunken hearth,
or *kang*, and short-legged tables were placed over this, so that the term "*kang*
table" came to mean anything in these proportions. They have naturally become
extremely popular in the West to fill the role of the central display table in a living
room. Chinese, Japanese and Thai low tables are the most popular, and as the
three examples here show, they have much in common. Because they are short,
the legs for low tables pose no special structural problems, and they tend to be
sturdy, but also quite stylized. Inward-curving legs are common, as are lion's foot
and claw legs. Broad and long low tables were little different from the construc-
tion needed for daybeds, and the two uses became interchangeable. Indeed, in
Thailand, low tables and beds were the same piece of furniture.

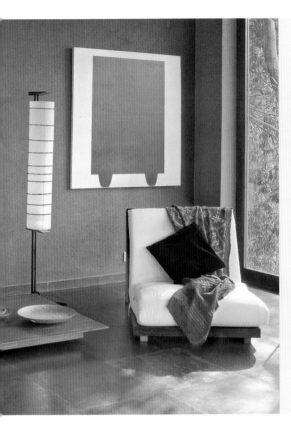

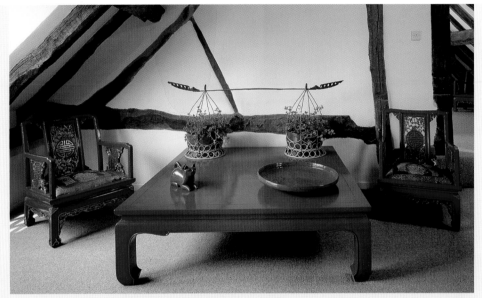

Left With a shallow central base, this low table, designed by the architect Samira Rathod, seems to float over the brown Mandana stone flooring in a weekend retreat near Mumbai.

Above A Chinese *kang* table makes a surprisingly fitting complement to the exposed timberwork of an English Tudor house.

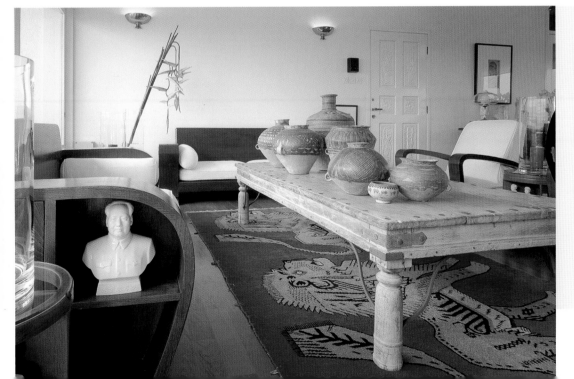

Opposite above left A small, low, circular Qing table sets off the simplicity of a narrow *tatami* room in a conversion of an old Shanghai building by Taiwanese architect Deng Kun Yen.
Far left The plinth of this simple square table designed by Japanese architect Enryo Furumi for his own house is also a slide-out drawer.
Left A rural Indian bed becomes a broad coffee table in an eclectic mix of furnishings that includes a Mongolian rug, a 1930s art deco curve-walled side cabinet, and Mao busts.

ASIAN ACCENTS AND FURNITURE

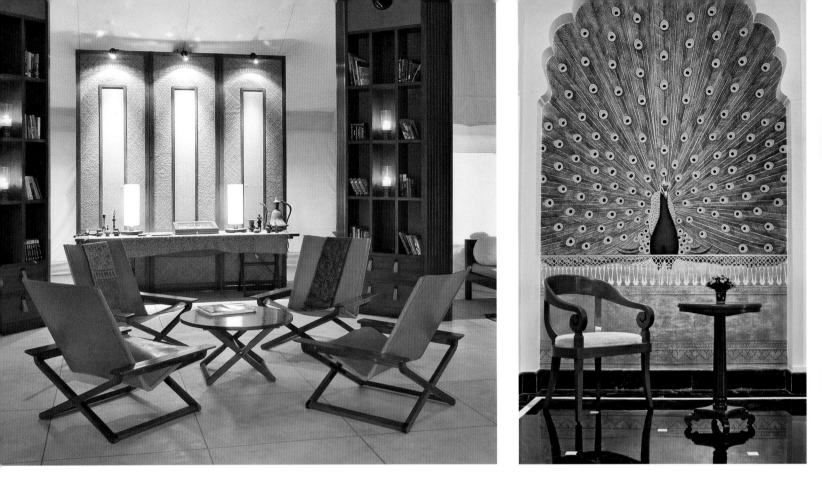

A VARIETY **OF SEATING**

The Chinese chair, though hugely influential throughout much of Asia, is no longer the dominant form. During the colonial era, the Indian subcontinent absorbed Western seating design and furniture, and more recently architects and designers have been creating their own designs, some referencing local Asian traditions, others taking cues from the West.

Above left Specially designed for this luxurious tented camp in Ranthambore, Rajasthan, these low reclining chairs are in framed hide on non-folding X-struts.
Above right A scroll-ended curved chair in an alcove painted with a peacock mural, in a hunting resort, also in Ranthambore.
Left A whimsical corner bathroom chair in the Rajput mother-of-pearl inlay tradition, designed by Mirjana Oberoi.

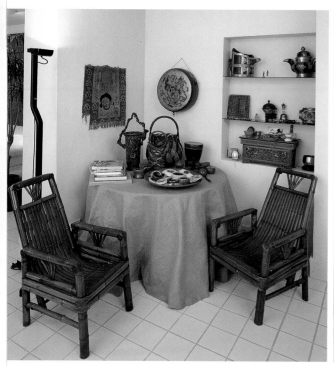

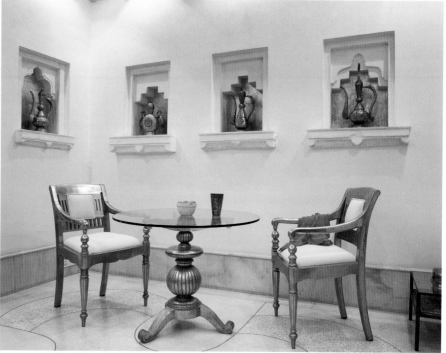

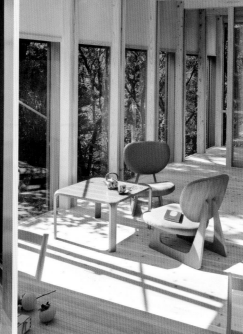

Above left A pair of sturdy rustic Chinese chairs in bamboo.

Above In this conversion of a Rajasthani fort near Udaipur, the wooden furniture has been covered with thin silver sheets beaten into the surface.

Far left A pair of side chairs and floral display turn an end-of-corridor window into an elegant display.

Left Low chairs designed by Japanese architect Chitoshi Kihara for a rural weekend retreat feature rounded bentwood backs and seats on angled frames.

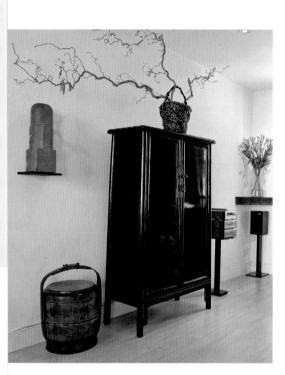

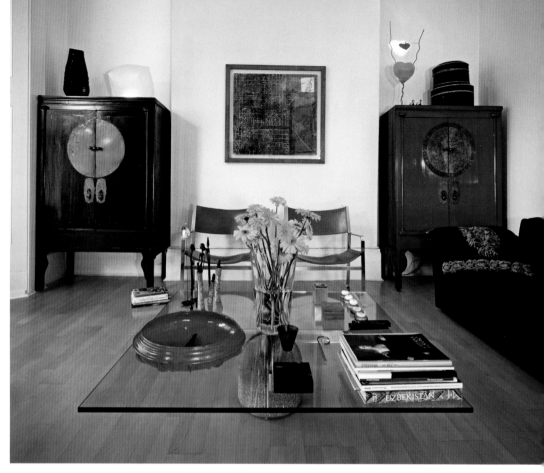

Above A black-lacquered Chinese cabinet in the distinctive tapered style. With the sides leaning inward, a single piece of furniture makes an imposing statement, at the same time projecting a more delicate impression than would a similarly sized rectangular piece.

Above right A living room furnished with two Chinese cupboards, one lacquered black, the other red, which frame the central glass coffee table.

Right An antique Korean medicine scholar's chest, with a profusion of small drawers, is useful for storing small items. Its relatively low height is ideal for display, here Karen baskets from northern Thailand.

Far right A *kuruma-dansu*, or Japanese wheeled chest, with characteristic horizontally ribbed sliding doors. The unusual design, which became popular in the late seventeenth century, gives it special character in a contemporary home.

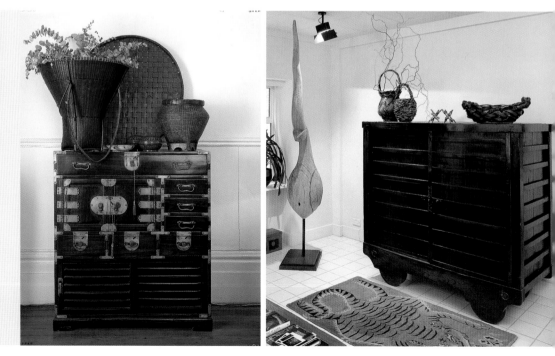

ASIAN CHESTS
AND CUPBOARDS

Japan's *tansu* are well-known and very specific, but chests and cupboards have always been popular throughout Asian cultures because houses were generally not constructed with built-in closets. As there is also a history of floor-level living in many parts of the region, there is a large class of low chests and cupboards. Korean furniture is particularly well known for this, such as in the form of the *bandaji*, or "blanket chest," and the *ham*, a box for items of special significance. Most Korean furniture of this type that survives is from the last century of the Chosun dynasty (1392–1910), and is highly regarded for the great attention paid to the grain, tone, hues and texture of the woods used, as well as for the ornamental brass fittings and hinges.

As for Chinese cabinets, there are traditionally two main types based on their overall form. Tapered cabinets, which usually follow the recessed-leg pattern of construction, have sides that slope gently inward from base to top (known as a batter). Square-cornered cabinets have vertical sides and are constructed with a mitered mortise-and-tenon box frame. We deal with the highly decorative Thai cabinets separately on the following pages.

A large Chinese country-style cabinet from the Qing dynasty features a delightful contrast between the extreme simplicity of the main construction and the carved panel between the legs. In the foreground is a deep red-lacquered Chinese box.

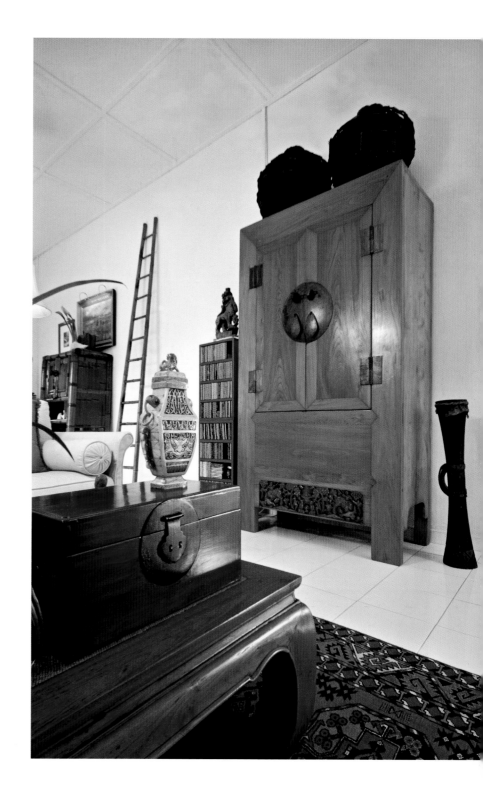

Right A low Korean cabinet with upper cupboard and lower set of two drawers. A profusion of decorative white or yellow brass fittings was typical.
Far right A tapered Chinese cabinet from the early nineteenth century in *jumu*, or southern elmwood.

Below A Chinese red-lacquered wedding cabinet adds a strong color accent to the white finish of a bedroom.
Below right The understated lines of two dark Ming pieces, a tapering cabinet and a camphorwood clothes chest, complement perfectly the contemporary white theme of this living room in Hong Kong.

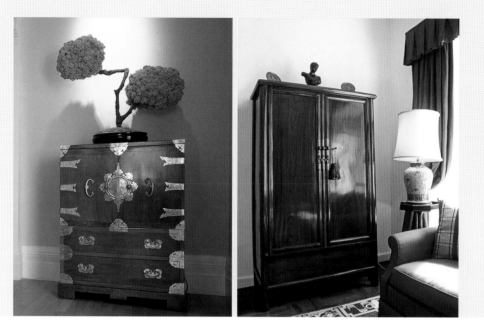

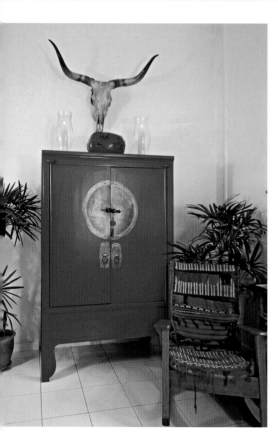

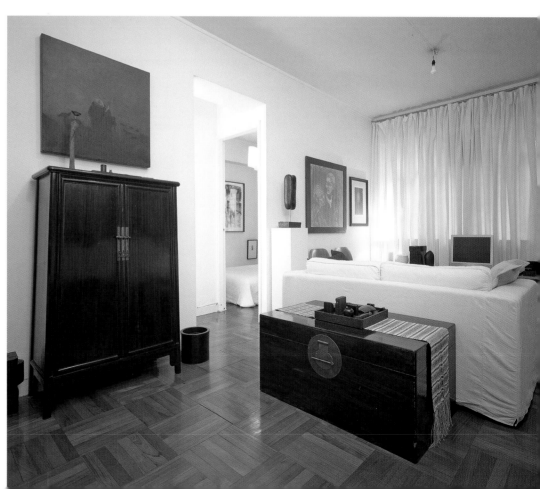

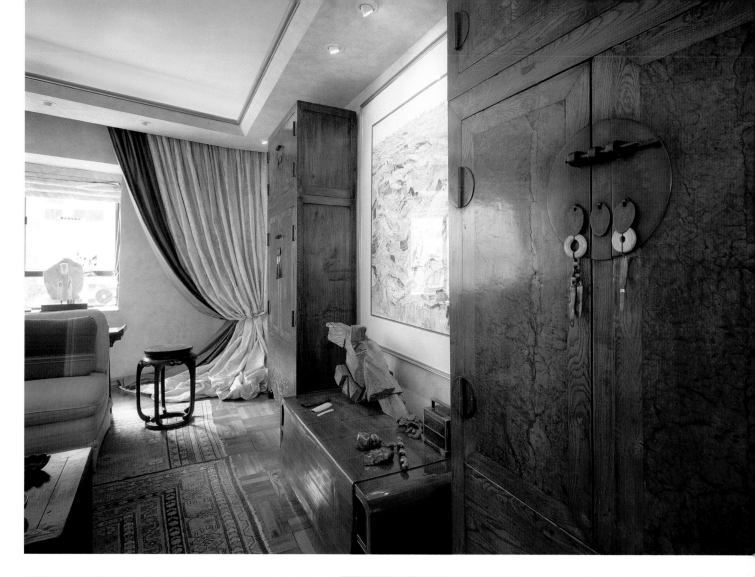

Above A pair of tall Chinese compound cabinets dating from the nineteenth century, the farther one in *yumu* (northern elmwood), the nearer one in distinctive *hamu* (burlwood). Their height and severe geometry give them a commanding presence in the Hong Kong apartment of Kai-Yin Lo. They were originally designed as wardrobes.

Right A pair of sloping-style wood-hinged cabinets from the Ming dynasty, particularly valued for the careful matching of the wood grain on the pairs of vantails, frame a doorway that leads through to a passage and a calligraphy scroll by a twentieth-century master, Qi Gong.

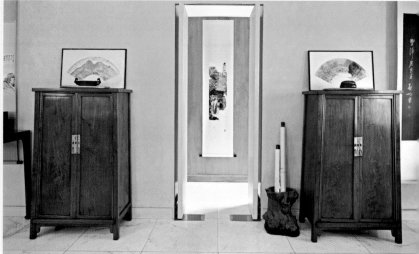

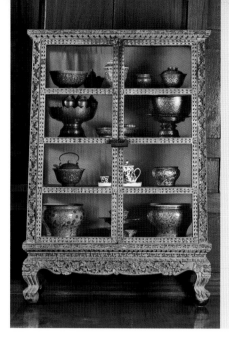

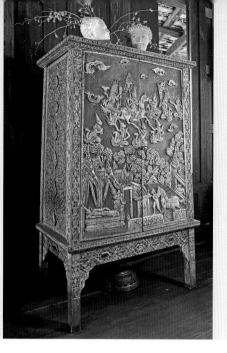

Far left A glass-fronted display cabinet with lion-footed legs. The Thai love of decorative objects and the importance of craftsmanship made glass cabinets popular from the early nineteenth century.
Left A teak cabinet carved in robust relief and gilded. Scenes were typically of religious or mythological scenes, with the Hindu epic, the *Ramayana*, a favorite theme. The tapering form typical of almost all Thai cabinets was inherited from the Chinese.

THAI CABINETS

The highly decorative carved Thai cabinet owes much to Chinese designs, although it is much more detailed and elaborate in finish than even late Qing pieces. This is partly because of Thailand's ethnic origins (principally from the south of China), and partly because of the surge of enthusiasm at the royal court for things Chinese in the late seventeenth century. Secure and dry storage was important in a country with such a humid climate, and as many of the more important pieces from the Ayutthaya period are religious in purpose, for storing Buddhist texts safe from humidity and insects. In addition, Thailand has a strong tradition of decorative crafts, and the aristocracy have long been collectors of such things as mother-of-pearl inlay, miniature *khon* dance masks, lacquerware, silverware and so on. All of these needed to be displayed, and the Thais, for the climatic reasons just mentioned, preferred to keep them in cabinets rather than exposed. Hence, under Western influence from the early nineteenth century onward, glass-fronted cabinets became very popular. Thai decorative skills were fully applied to this range of cabinets in the form of bas-relief carving, gilding, lacquering, and gilded lacquering (a specific treatment at which the Thais became experts).

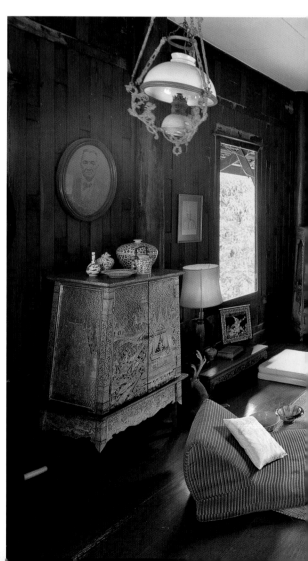

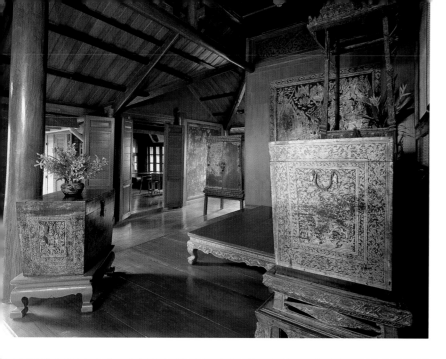

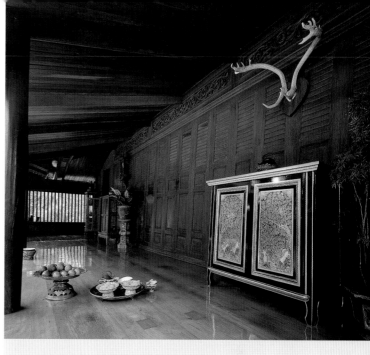

Above left Two Ayutthaya-period gold-on-black lacquer chests. These were originally used for storing clothes or books if secular, or if in a monastery for archiving Buddhist scriptures. Behind is a tapered cabinet from the same period.

Above A fine and restrained wide tapering cabinet in black lacquer with framed panels of gold lacquerwork depicting scenes from the Himaphan forest in the *Ramayana* epic.

Left The Thai custom of sitting on the floor, even in wealthy traditional homes like this one, resulted in much of the storage furniture, such as this tapering cabinet, being low and squat for ease of access.

Below Another glass-fronted cabinet, but double width, used here to display Bencharong ceramic ware. The back panel of such cabinets was typically painted a distinct color, such as red or, in this case, green.

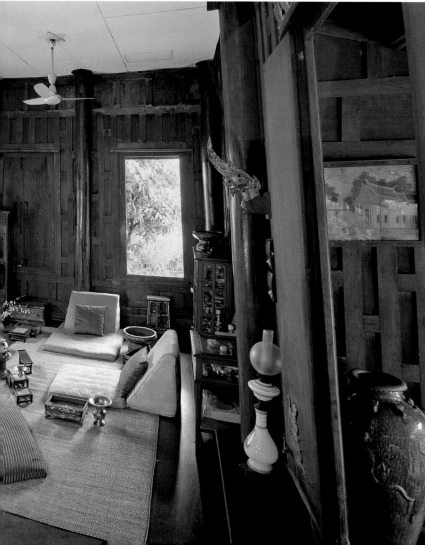

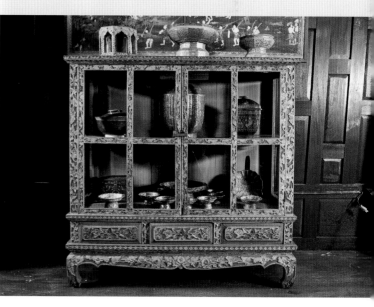

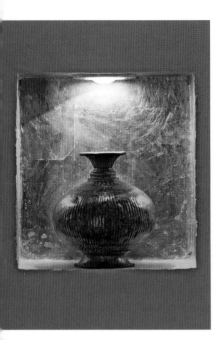

SHELVES AND NICHES

For similar reasons that made side tables and narrow altars such a feature of many Asian homes, niches, small alcoves and other recesses are a part of the tradition. Originally, most niches would have contained religious icons, such as a Buddha image or a statue of Ganesh, and the practice became well established. Most of the examples here come from India, but in all cases they have been given a make-over by the designer. Adding color to the interior of a niche brings it to life, particularly if set in a plain white wall, and in one case here an ancient technique, which involves making tiny pillow-shaped mirrors by hand blowing glass and coating it with mercury before breaking it, and then arranging the pieces like a mosaic, has been revived. Installing lighting, such as a downlighter or uplighter, further brings it to life. What remains is choosing the appropriate object or collection to fit the space. In the examples here, these run the gamut from vases to brightly painted models of birds.

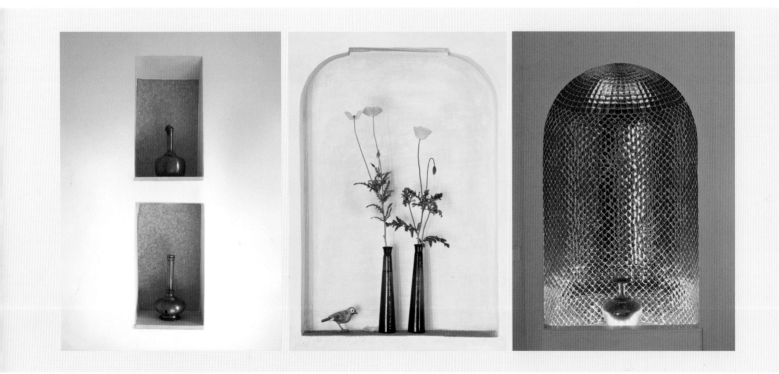

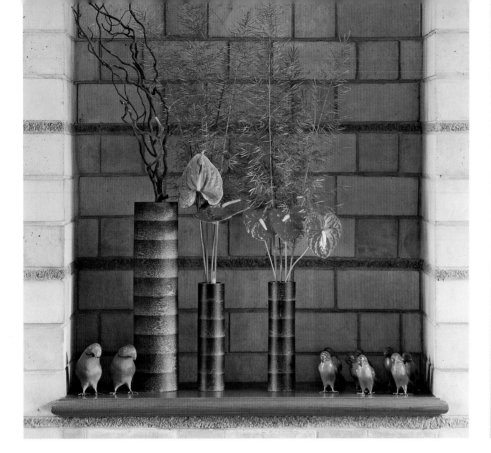

Opposite above Gold leaf squares have been applied to the interior of this niche, and pick up reflections and texture from a single downlighter.

Opposite left Splashes of color lighten the conversion of a seventeenth-century stone fort. Designer Rajiv Saini here applied orange on the rear surface as a backdrop for a collection of small brass vases.

Opposite center A pale yellow dragged finish over a shallow niche in a Rajasthan *haveli*. Slim flower vases and a painted wooden bird provide suitably rustic touches.

Opposite right Modern *thekri* work in a domed niche. This consists of mercury-coated curved pieces of glass laid in mosaic fashion.

Above left and right A simple recess in interior brickwork provides a display area for a whimsical collection of emerald green parakeets and cylindrical wood flower vases. A tall cylindrical glass filled with pebbles and thistles ideally fits the vertical niche above.

Below In the entrance hall of a contemporary Delhi apartment, a row of shallow stone dishes filled with marigolds alternates with a row of uplighters.